U0144121

從事與設計或創作有關的工作者，
應該每天都在品味工作的
獨特性、有趣性、深奧性，
而不論從事哪種行業，
不論位處哪個職階，
都一定會時而煩惱、
時而自問自答的面對自己的工作。

不妨利用工作空檔時間、
通勤時間、移動時間閱讀本書，
因為本書網羅了建築設計、藝術設計、
家具製作、不動產顧問、拍照攝影、
PR、照明設計、服裝設計、
花藝設計、編輯等，
10位活躍於設計與創作業第一線的專家，
提出工作所需的關鍵思考、創意與建議，
將他們從經驗中得來的
意寓深遠的意見匯集成冊。

本書沒有所謂的章節或單元，
不妨翻開你喜歡的頁數，
從中尋找你現在迫切需要的意見，
相信濃縮在裡面的智慧，
能幫助你得到有助目前工作的提示，
確實引導你走向色彩繽紛的未來。

創意無界！
優秀設計人
思維大不同

堅持當第**1**個
嘗試的人

Be the first to get there

蕭規曹隨，不要成為跟隨在後的曹參，要成為引領在前的蕭何。要擠下眾多競爭者取得第一名寶座或許不容易，但要搶在人做「第一個」嘗試的人卻並不難，何況第 1 個做的人總是搶眼的，因此要抱持「誰都不做就由我來做」的態度邁步向前。

Don't be someone who just picks up the slack – be the guy who blazes the trail. You might not succeed in becoming the absolute top dog in your field, but you can be the "first" to get there. Just being the first to have tried something will make you stand out. Tell yourself, "I'll do it myself since nobody else will".

START

要擁有

Have groundless self-confidence

毫無

根據

的自信

GOAL

試著放膽直接說出你的結論,即使會嚇到旁人也無所謂,只要事先思考好導出你結論的過程,再配合狀況持續往前邁進就行了。

Try saying something sweeping and conclusive once in a while. Who cares if you end up startling a few people? All you need to do then is to think about how you're going to reach that conclusion, and play the game according to the circumstances.

別 剔
什麼都要試試看

Don't be picky-
get a taste of everything

是偶然還是必然？要如何面對突如其來的機會？「no thank you（＝不用了）」無法帶來任何結果。designer 與其說是職業，不如說比較像是人生方式，所以日常應儘量接觸各種價值觀，別因好惡做選擇，什麼都要試試看，即使結果不順利，只要將所有過程視為一個大的設計階段就行，就當作是在設計人生⋯⋯。

Do things happen by coincidence, or out of necessity? How should you tackle an opportunity that suddenly comes your way? Nothing will come out of a "no, thank you". Design is a way of life, rather than an occupation – they set out to make sure they have the time and freedom to sample a little bit of everything that life has to offer them, without being too picky. Even if the end result doesn't go the way you planned, just treat the whole process as a single, massive phase, just as if you'd intended to design your own life…

時間 方面 要 設法 趕上

Meet those deadlines

設計是在有限的公平時間內，設法留下更多成果的創作性遊戲，所以不論有多棒的好點子，要是時間上來不及，就只能遺憾的獲得零分。有些人會找藉口說：「要是能再多給我一點時間就好了。」但這都是過度自信的表現，面對工作的基本態度與對時間的掌握度，都會明確表現在設計工作上。

Design is a sort of creative game where people compete to see how much of a lasting impact they can achieve within the same limited span fo time. No matter how amazing your idea is, no points are awarded if you don't make it in time. You can't place too much good faith in staff who make excuses like "I would've been able to do it if I had more time". Your basic attitude towards work and sense of discipline show up very clearly in the desings you produce.

梅洛斯！！

要 質 疑 預 算

Be suspicious about budgeting issues

要仔細思考「真有必要將錢花在這種地方嗎？」這個問題，才能有
助於設計，因為並非只要有錢，就能得到完美的設計，通常反而都
是適得其反。

Giving serious thought to whether you really need to spend money on
one thing or another is an essential aspect of design. You're not going
to end up with a good design just because you have the money – it's
actually the opposite.

乘著既有的

波浪

Ride the waves
that are already there

比起自行創造的潮流，世界上潮流的力量則更為強大，因此不需一開始就浪費自己的精力去製造波浪，試著冷靜觀察既有的波浪並分辨清楚吧！因為只要順勢乘上好的波浪並順著潮流前行，就更能簡單的從中創造出自己的潮流。

The trends and currents that are already out there in the world flow much faster than anything you might create on your own. Rather than expending all that energy and getting all passionate about starting the next big thing on your own, study what's already out there, and separate the wheat from the chaff. It's easier to get into the game if you latch onto a wave and ride the current for a while before striking out on your own.

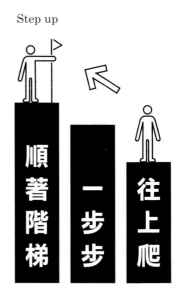

Step up

順著階梯　一步步　往上爬

決定要從事設計工作後，首先要設法努力向他人展現實績，然後再朝著能由自己主動提出設計收費方式的目標前進。等累積足夠的工作經驗後，就算要付出較高費用，也要增加值得信任的工作伙伴。如果最後能自由選擇自己想做的工作，並依自己的時間來進行，那才是最高的境界。

Once your design career has begun, work hard to make achievements that can be shown to others. Then pursue a status that allows you to offer your desired design fee. When you gain enough work, increase the size of your staff and aim for a status where clients offer you jobs for high fees. It would be wonderful to be able to choose work that you want to do, and to create free time at the end.

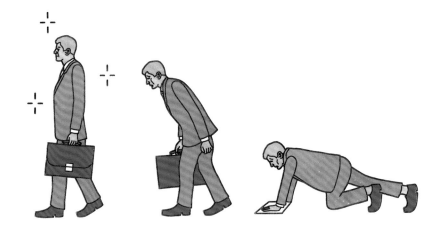

黏著不放

Stick with it

在期限內都要黏著不放、黏著不放，始終黏著不放。在漫長的過程中，真正的答案只存在於最後狀態的短短瞬間，所以不能有絲毫的鬆懈，唯有黏著不放直到最後，才能完成真正的設計。順帶一提，設計原本就是黏人的工作，非常需要體力，所以我們公司徵人時會問對方：「你體力好嗎？」唯有回答：「我對自己的體力有自信！」的人才會被採用。

Persevere, persevere, and then persevere some more within a limited span of time. The real answer can be found only in a single moment at the very last stage of a long process, so you have to be sure not to slacken for even an instant. Designs come to completion by sticking hard and fast and not letting go. It's a demanding, physical operation. At my own firm, we only hire people who are confident about their own strength and physical health.

同時

遠 看業界

並 近 看業界

Look at your industry
both up close and from afar

業界的常識有時不適用於一般社會，而一般社會所認定的常識，也
有可能不適用於特定的業界，因此必須隨時擁有看待兩方的視野。
「如果我是負責製作的人」、「如果我是客戶」，唯有同時站在不
同的立場思考，才有辦法從磨擦中找到平衡點，讓事情進行得更順
利。

What might pass for common knowledge in one industry sometimes
doesn't apply at all to normal life. Similarly, even what one assumes to
be common practice may not hold in certain specific contexts. Remem-
ber to always look at things from both these perspective. By imagining
yourself to be in the position of the creator, or the client, and going
back and forth between these viewpoints, you'll be able to overlay one
on top of the other and everything will work out well.

Set a target

鎖定目標

設計不同於藝術，必須配合客戶來創作，因此鎖定能瞭解自己設計
的特徵，而且能接受這種設計特徵的人為客戶，才是最重要的事。
如果想和不同層次的人一起工作，就必須擁有更寬廣的設計幅度。
擁有戰略是商業基本法則。

Unlike art, a design is created depending on clients. It's important to
be familiar with the characteristics of your desing, and pursue client
groups who most accept your designs. To work with other groups, di-
versification of your design range is required. Having a strategy is one
of the basics of business.

25

展現出自己成長潛力的可能性

Show your potential
for growth

雖然事物本身具有色彩並非壞事，但卻會有導致無法成長的可能性。
相反的，具有能被染成必要色彩等可塑性的事物，才能讓人感受到
發展潛力。年輕人雖然經驗不足，卻擁有相當大的潛力，而想一睹
潛力的可能性（才華）時，通常前輩們都會願意伸出援手，客戶們
也有可能委託工作。不必畏懼自己不懂的事，應該謙虛向學，並展
現出自己的成長潛力。

Having a distinct, fixed quality to your work is not in itself a bad thing,
but the room for growth in someone who's still inexperienced is much,
much greater. In contrast, there's lots of potential in a flexible attitude
that can adapt as necessary. What young people lack in experience,
they make up for in terms of potential. When juniors decide to develop
this potential and talent, their seniors ought to step in and help, and
clients should hire them for jobs. Don't be afraid of what you don't
know, learn humbly, and make that potential flourish.

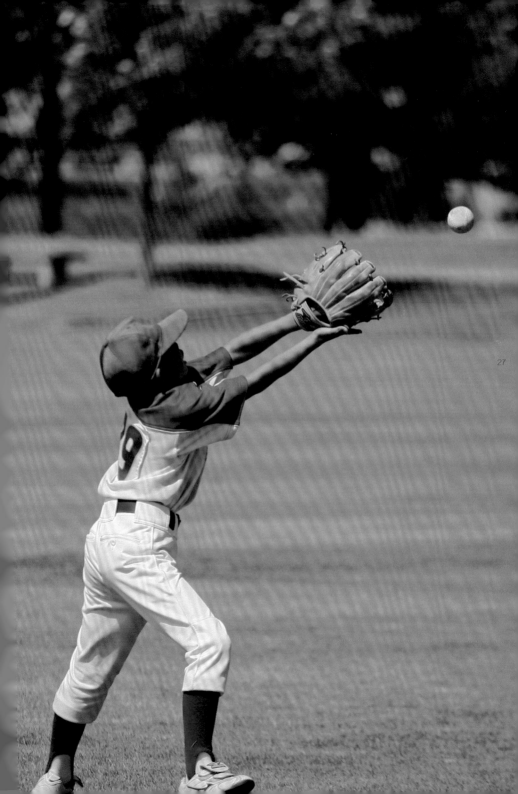

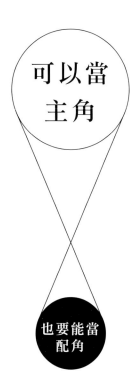

可以當主角

也要能當配角

Play both the lead
and supporting roles

依據專案改變自己所扮演的角色，才能培養出客觀性。要達到這個目的，必須與多數人一起共事各種不同領域的工作。如果每次都和相同的人一起負責同樣的工作，就無法增加變化，也無法培養出彈性思考的能力。不論主角還是配角，唯有兩者都能扮演得維妙維肖，才是真正有能力的人。

You learn to become more objective by assuming different roles depending on the project. In order to pull this off, you need to work with lots of people on all sorts of different projects. If you only work on set projects with the same group of people, you're not going to gain breadth, accomplish change, or get a more flexible and versatile handle on things. The ultimate goal is to become able to play both the main role and the supporting one.

思考
別人對你的
期待

Think about what's
expected of you

當設計師接到工作委託時，如果是色彩鮮明的資深設計師，通常會被客戶期待該設計師特有的路線圖，但要是沒有經驗的設計師，此時又會如何？身為設計師不妨自行思考看看，別人對你有什麼樣的期待，是「氣勢」、「變化性」還是「新感覺」？只要明白這一點再來設計，或許就能省下許多無謂的交涉。

When veteran designers accept commissions for work, clients often expect results that mirror the style or idiom that those designers have become known for. What about designers with no experience, though? Maybe designers should also think hard about what's expected of them – is it energy, unpredictability, or freshness? Just by going about your work with this in mind, you might be able to rid yourself of time-wasting, unproductive exchanges.

思考

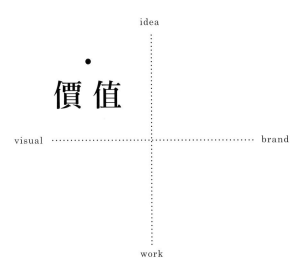

idea

價值

visual .. brand

work

的所在

Consider where the value exists

在此思考看看客戶要支付設計費時，是為了什麼而付款？是勞動、品牌、創意或是美麗外觀？如果對方所認定的價值，與我們想追求的價值不一樣，就會產生代溝。相反的，若能一致，就能為彼此帶來極大值的商業利益。

Think about what the client pays for with the design fee, such as labor, brands, ideas, or beautiful visuals. If there is a gap between the values that the client recognizes and the values you want to pursue, the relationship will be distorted at some point. Conversely, if your values match, you should be able to maximize each other's business.

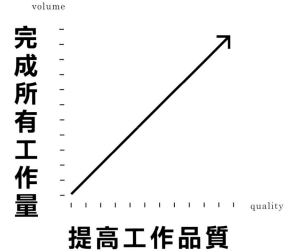

volume

完成所有工作量

quality

提高工作品質

Boost quality by increasing volume

這是質量轉化法則。同時處理各種充滿變化的工作，能讓設計的創造力獲得飛躍性的增長。不論直線進攻、迂迴前進或是中途折返，都能大大累積經驗，最後不論再高的山也能攀登。某個專案的提示，經常被隱藏在另一個專案裡，而看似徒勞無功的事，也往往隱藏著解決問題的線索，甚至繞遠路更能看到全新的景色。比方說雜耍表演必須一次同時扔耍許多東西，而這種充滿活力的狀態，就是衍生出新事物的最佳狀態。

Big masses tend to undergo a transformation. By pursuing all sorts of varied projects at the same time, your design creativity is going to expand dramatically. Over the course of trying direct, head-on approaches, making detours, or retracing your steps, you accumulate experience and become able to tackle even the most daunting obstacles. The key to one project is often hidden within another. Hints to solving a particular problem can sometimes lie precisely within something that seems utterly useless. Going around in circles and taking the long way around can reveal a new vista. The dynamism to be found in many parts being activated at the same time, just like juggling, is the best situation in terms of making new discoveries.

也要盡量嘗試看看

Try it and see, even if someone
tells you otherwise

接到某個前輩的指示，甚至被教導該怎麼做，而在推行之後，卻又有其他前輩提出不同的建議，讓人深感困擾。內容相左的兩個建議，一個向左、一個向右，卻又不能停在原地不動，此時也只能忍耐，設法壓縮時間盡早完成作業。只要能以「竟然能一次獲得兩種不同的執行手法」來思考，就會覺得其實也還不錯。

So one of your seniors gives you instructions, and even shows you how to get something done. When you do as you've been told, though, someone else tells you that it should be done his way, which confuses you. You need to take a position, and choose if you're going to take your cue from your left or you right. Maybe it's going to take you twice the time and effort, but suck it up and get on with your work as efficiently as you can. Ultimately, you're going to learn two ways of getting things done, so just go for it. You could do a lot worse.

ANGEL

DEVIL

朝著
同一個方向
前進

Keep your eyes trained on the same target

客戶與設計師經常會忍不住認真起來，彼此察言觀色後再和對方交涉，但其實不妨試著不要正面對決，而是與對方看往同一個方向。如果能營造出朝著相同方向前進的「感覺」，那就再好不過了！不要將客戶視為敵人，應將客戶轉為同伴。

Designers and clients tend to be too uptight when they meet, haggling with each other while trying to figure out what the other is thinking. Instead of being so high-strung and confrontational, let's try seeing eye to eye, and look in the same direction. Once it feels as if we're headed in the same destination, it's a done deal. Don't think of your client as your enemy, but as someone on your own team.

從契約流程來衡量危險性

Use the contract-signing
process to measure the risk

遲遲不跟你簽約的客戶，基本上不是還不相信你，就是想騙你。若真心想委託你幫忙設計，照理說沒有理由不簽約。再者，已經答應你要簽約，卻遲遲沒有採取行動，同樣是危險訊號。設計要想成立，絕對條件就是建立彼此的互信關係，所以此時應立刻停手，以牽制對方。有時必須懂得急流勇退，既然尚未簽約，就代表你還是自由之身。

Basically, if a client does not sign a contract, they do not trust you or they are trying to deceive you. If they truly intended to offer you a job, no obstruction should exist to signing a contract. It is a danger sign when the client agrees to make a contract but the contract process does not preoceed smoothly. An absolute requirement for design is the establishment of a mutual-trust relationship. Stop immediately and warn the client. Sometimes having the courage to walk away is required. Having no contract means you are also free.

應 設 法 增 加
理　　解　　者

Get to know more people who understand you

如果想做自己想做的工作，就要設法增加周遭能理解你的人。總之先向他們傳達你的想法，闡述你的思維，講解你的概念，同時證明你對該工作的熱愛勝過任何人，也能堅持做下去。因為獨自一人能做的事有限，所以必須和老闆、工作伙伴、客戶共有夢想。只要能擁有共同的目標，以及能達成目標的意志力，就能大大增加所能成就的事。

If you want to do the jobs you want, start by getting to know people who understand what you're about, one by one. More than anything else, you need to communicate what you're thinking, describe your thought processes, demonstrate what you mean – and prove that nobody has a greater passion and knowledge than you do for the subject in question. There's a limit to what a single person can do. Share your dreams with your boss, colleagues, and clients. When you share common objectives and have a frame of mind that will lead you to accomplish them that, the things you'll be capable of are going to increase dramatically.

時機 **》》**
《《 就是一切

Timing is everything **》》**

好的設計能吸引人的關鍵，在於掌握了時機，因為 PR（promote）效果都只發揮在一瞬間。即使有再棒的照片或圖面等資料，若不能趁新聞還新鮮時進行 PR，就沒有任何意義。

The key to getting a good piece of design noticed has everything to do with the right timing. Even an effective PR campaign only works for an extremely brief window of time. No matter how amazing your photography, diagrams, and other materials are, they won't mean anything unless you get your PR out there while it's still fresh and can make a good news item.

在 工 作
這 一 點
千萬別忘了

Don't forget who you're working for

清楚掌握「為誰工作、做什麼工作」這一點，能成為直接又簡單的
原動力。工作時應一邊思考我所提供的服務，是為了誰的未來好，
又該如何執行。

A clear idea of who or what you're working for is a direct and simple
source of motivation. Make sure you keep in mind whose future the
service you're providing is helping to build, and how it's going to cre-
ate that impact.

就算像　伴隨　大便一樣不起眼也無妨

Shadow people

平常退後半步跟在前輩後面，偶爾搶先一步做好事前準備工作。只要始終跟隨同一個前輩，就能學會如何執行工作，這比自己苦思要來得快，所以不妨緊緊跟隨在後。

Walk just behind your superiors to flatter them and make them feel good, but once in a while, stay one step ahead of them to make sure things are ready. You'll remember how to get things done if you keep shadowing the same superior. Cling to them like a leech – it's much faster than trying to work it out yourself.

想要見到誰就去見吧

Go meet the people you've always wanted to

剛進入這個業界時，根本分不清左右方向，也沒有所謂的業界指南可依循，能作為提供給對方的憑據的，只有想去看看對方工作的慾望。抱持這種輕鬆的動機前來，或許會讓對方覺得很困擾，不過這種想看、想去的慾望，卻是工作的根源，應好好重視。

When you just got started in this business, you didn't know your left from your right, and had no idea how the industry worked. The only thing you could use to situate or contextualize the person you were working with was the job itself. That sort of innocent, carefree motivation might have been something of a nuisance for all involved, but the desire to see things and go places if something that you should cherish as the basis of your work.

設法提供

更（多）的選擇

Provide lots of options

向客戶提供足以用來比較的材料，並出示你進行思考的整個過程，
避免最後落入獨斷的裁決。比方以數位拍攝照片為主的現代，或許
在現場沒有太多時間與空間可用，但至少能從各個不同的角度多拍
幾張。

Be careful that the finished product doesn't become something dog-
matic and unilaterally decided on by providing your collaborators with
materials that they can weight against each other, and making clear
how your won thinking process devekoped. Even now, when digital for-
mats have become the norm for photography, you can still shoot from
multiple angles even with limited time and space at the given location.

盡量什麼都提出疑問

WHAT WHY HOW WHERE WHO

Ask anything

首先得累積自己應瞭解的設計相關知識。在還搞不清楚方向時,要盡量向前輩、生意上的夥伴、生產現場的專業人員們發問,並當場牢記下來。雖然俗話說:「年輕時的恥辱不是恥辱。」但實際上很少有人能坦率向人發問自己不懂的事。有辦法立刻提問其實是一項「才能」,而且用這種方式花時間學來的知識,永遠也不會背叛你。

First, you need to store knowledge about the designs you will be working on. If you are confused, ask any question to your predecessors, business partners, or workers at a production site, and learn practically. It's ofter said, "shame in your youth is not shame", but only a few people can actually be honest and ask about what they don't know. The ability to immediately ask is a "talent". Then knowledge acquired through taking the time won't disappoint you.

55

要隨時保持開朗的態度

Always be in a good mood

沒有優秀的表演者會露出不悅的態度,因此真正懂得設計秘訣的表演者,也都是真正的溝通者。將表演者一身苦惱背負在身上的不悅態度,往往是沒有自信的表現。

I don't know any top creators who go around with a long face all the time. Designers who have a real grasp of the tricks of their trade are real communicators. A sullen face that carries the weight of its troubles on its own shoulders is often just the flip side of a lack of self-confidence.

57

戒

慎 恐 懼 Stay timid

對象當然是指人們，因為畏懼能讓我們更慎重與仔細，而心存畏懼
對對方而言也是件好事。

We're dealing with people here – being timid helps you to become
prudent and discreet, and is beneficial for the other person as well.

59

從小事
慢慢
累積

Peck away steadily
at the small stuff

準確又仔細的行事方式非常重要。埋下種子後只要每天澆水，終有一天會開出美麗的花朵。這麼一來就一定能獲得「深深感動前來看花的人，讓對方想再度前來觀賞！」、「對你衍生出想讓這個人幫我培育，想委託這個人」的結果。

Careful, diligent, and steady work pays off. Beautiful flowers bloom when plants are watered and cared for every single day. People who see your work will be impressed, come back for more, hire you back again, or want to come under your wing.

營 造 出 好 的

Keep the
atmosphere comfortable

有時工作結果會受到現場的人影響，當然這影響有可能是好的，也
有可能是壞的，所以應儘早營造出好的氛圍。

The people who are present sometimes influence results – in a good or
bad way. Make an effort to create a comfortable atmosphere early on.

試著找自己

不擅長應對的人商量吧

Sound out people you
don't really click with

當工作遇到瓶頸時，如果找想法和自己比較相近的人，或是和自己
交情比較好的前輩商量，只能得到設想中的答案。這時候因為是在
自己想像範圍內的活動受阻而遇到瓶頸，所以得到的答案往往只是
會讓自己感到安心，並無法真正解決問題。既然是超出自己能力範
圍的事，還是放膽去找自己不擅長應對的人商量吧！這麼一來或許
就能得到完全相反卻非常新鮮的意見。

If you discuss things with people who think like you do, or with supe-
riors that you have a good relationship with when you're stuck, you're
going to get answers and advice that you anticipated anyway. You ran
up against a wall while engaged in something that didn't exceed the
scope of your own imagination, so this approach doesn't usually lead
anywhere. This is a problem that's too much to handle by yourself, so
take a risk and ask someone that you might not be completely comfort-
able with. You might actually hear a new perspective on your plight.

從閒話家常中

閒出

對方的需求

Determine what the client wants
through small talk

客戶經常會在還沒有具體的想法下，就前來委託設計師，有時還因
無法花費太多時間在案件上，甚至乾脆全權交給設計師負責，但在
完成後又要處處挑剔，而讓整個設計案遲遲看不到結果……雖然這
是常有的情形，但某種程度上只要彼此經常溝通就能避免，不妨從
閒話家常中找出對方的興趣與偏好。

Clients often commission work from designers before they have a
concrete idea of what they want or need. Sometimes they don't have
the time to spend on the project, while other times they just trust the
designer to do what's best – before coming back to nitpick and find
fault with what you've come up with. This results in a poor idea of what
the final product shoule be. This situation is extremely common, but
thorough communication between the two parties can help to prevent
it. Try to suss out your client's tastes and preferences by making small
talk with him.

試著擁抱 現狀吧

Clinch

要是怎麼做都無法突破現狀，不如就擁抱現狀吧！因為一記漂亮的直拳已經無法發揮作用了。刺拳、刺拳、防守、刺拳、防守，事情不見得都能依自己的步調進行。

Try clinching if it looks like you aren't going to get anywhere. A clean, straight punch rarely gets the job done. Jab, jab, guard, jab, guard. This doesn't just apply to your own pace.

試著正確的
掌握自己
的狀況

Size yourself up accurately

千萬別忘了還有緩降斜坡這個選項。要是遇到遲遲無法成長，因找不到解決方法而掙扎的狀況時，就別一直停滯不前，應該緩緩的順勢往下走。停滯等於後退，絕不能讓自己在原地踏步。

There are no flat and even paths you can take when it comes to work. But are you going to notice when the terrain starts to slope downwards ever so slightly? Without realizing that you've quietly started to slide downhill, you find yourself with the mistaken impression that you're still at a point where you're not making any progress. Nope, you're actually starting to regress, my friend. Pay attention if you're slipping, no matter how gentle the gradient might be. You'll be going upwards the next time around.

pile

要瞭解自己

Know yourself

瞭解自己的優缺點是非常重要的事，就連運動界也普遍存在這個常識。以設計業來說，若無法清楚展現自己的特長，就無法順利工作，因此就算是刻意訓練，也要突顯自己的優點，因為此時不但不會樹大招風，反而能帶來機會，所以不必畏懼，一定要貫徹自己能為之事。

Like in sports, it's important to know your strengths and limitations. For designing, work won't be accomplished without clear characteristics; therefore, emphasize your strengths, purposely or not, and be a "stake that sticks out". The stake sticking out won't be beaten but grabs an opportunity. Then, do what you can do, both fearlessly and firmly.

試著共有
對方所擁有的
新鮮度

Tap the freshness of your collaborators

即使對我們來說不過是反覆進行的事，但有時對對方而言卻非常新鮮，因此別忘了這一點，也別吝於提供從跨領域、持續性工作上所獲得的知識與發現。只要共有新鮮度，或許又能獲得全新的發現。

Don't forget that your collaborators are always going to have something new and fresh to bring to the table, even if you've done this a thousand times. Bearing this in mind, make sure to generously offer them the knowledge and discoveries that you've acquired over the course of your genre-crossing career. In the same way, you might make some other discoveries by sharing this sense of freshness.

実家から届いた
採れたて新鮮野菜！

今日の晩ご飯で早速食べます♪

いいね！・コメントする・シェア・昨日 13:46・

TARO YAMADA さんと他41人が「いいね！」と言っています。

他19件のコメントを表示

田中一郎 おいしそ〜！実家から届くなんてうらやましいよ〜

16時間前・いいね！

Kenichiro Sasaki 新鮮野菜！本当に美味しそうだね♪
晩ご飯でも作ったらアップしてね！

重 置

並朝向下一個工作前進

Hit the reset button and
move on to the next thing

有多少種客戶存在就有多少種工作，因此當結束一個工作、朝著下一個工作邁進時，就應該重置（reset）先前的經驗，以全新的心情出發，因為成功經驗的累積，很容易讓自己陷入固定的工作模式。不論擁有多完美的經驗，也不能輕易引用，每次都應重置回中立的狀態，對創意工作才最有幫助。

Every single client you deal with is going to entail a different set of project specifications. If that's the case, you should hit the reset button on all your previous experience when one job ends and you proceed to tackle the next one, approaching it with a fresh mind. The reason is that you tend to become a parody of your own style if you rack up too many successes. In creative fields, what matters is doing the necessary preparation to ensure that you approach each assignment with a neutral stance, without drawing too readily from previous experiences, no matter how amazing they may have been.

成為
被徵詢意見的
存在

Become someone that
people talk about

要努力成為被認定是該領域的專家,設法在該業界鞏固自己的特殊性與位置,達到「提到○○就想到○○人」的目標。只要廣為眾人所認知,媒體自然會爭相採訪,增加你的曝光度。

Recognition will come if you're an expert in a particular field. Establish a unique, niche position so that people will automatically associate your name with a specific set of skills or expertise. Once people know about you, media coverage will naturally follow, and your exposure will increase.

試著做第1名的工作

Get experience with top
players in their own field

不論是多小的領域都無妨,一定要體驗過自認是業界第一名的工作,
因為「能獲得第一的工作」都存在有某些共通點。哪怕是非常微小
的領域,也要試著盡情呼吸一次該種空氣,這樣才能把它當作執行
任何工作時的應用基準,讓自己養成習慣。

It doesn't matter how small the field may be. Try doing a job at a place
that ranks among the top in all of Japan. There's bound to be some-
thing there – a job where only the best people are – that overlaps with
your own work. Once you get a good taste of the vibe of that place, no
matter how small the field might be, that experience will become a
kind of benchmark that you can apply to all of your own projects, and
stay with you forever.

活用
年輕與體力

Make full use of youth and stamina

因為還年輕，所以多的是時間。千萬別這麼想，唯有年輕時，才有人會像母雞帶小雞般的一一教導你，等你開始擁有後進後，就變成你得教導對方。擁有體力表示還有許多值得學習的事，一定要充分使用體力，每天拚命努力，因為現在是正值努力的時期。

There is plenty of time when you are young—this is a ridiculous lie. You are only attentively taught when you're young, and when you have younger designers you are placed in a position to teach. Having stamina means having plenty to learn. Keep trying hard every day until all of your stamina is gone. Now is the best time to try hard.

讓

熱情

理想

與

之輪同時轉動

Make both passion and theory work for you

空有熱情沒有理論，是很難將理想付諸實現的，而空有理論沒有熱情，則無法將理想傳達給人們明白。雖然熱情比什麼都重要，但若光有熱情，是無法說服他人一起工作。相反的，要是只有理論沒有熱情，這樣的工作也無法驅使他人跟隨一起執行。

Pure passion without theory isn't going to get you anywhere. Pure theory without passion isn't going to get your message across. Passion is more important than anything else, but you won't be able to get to do jobs that involve other people. Projects that only emphasize theory but are drained of passion, on the other hand, are not going to be able to move people into action.

不是「抄襲」
而是「仿效」

Don't rip off others, pay them a tribute

設計師原本就是以創造出與眾不同、世上絕無僅有的物品為職志，但這樣往往會本末倒置，明明客戶的目的是想看到成果，卻變成以創造出新東西為目的。因此不必擔心仿效，好的東西就是好，即使最後結果很類似，也代表出自你的尊敬，是一種敬意的表現。人都是透過模仿而得到成長。

What makes desingers different from other people is how they try to create things that don't already exist. So sometimes we tend to put the cart before the horse, thinking that the objective is to create something new, when what we should be doing is delivering the result that the client wants. The quality of a good product is self-evident. Even if a certain product ends up resembling something else, there's no doubt that it was conceived with the utmost respect for the original. People learn and develop by imitation others.

如果要模仿

那就

模仿概念吧

When you copy,
copy concepts

即使看到別的設計師完成優秀的工作,也別模仿該成果的外觀或形狀,因為再怎麼模仿也絕對無法超越。不過仿效設計背景來源的概念,則會很有效果。只要能理解該概念,並從中學習思考方式,就能加入自己的獨創性,展現全新的風貌。

Do not copy appearances or shapes from other designers' fine works. It's impossible to exceed the original work. However, copying the concept that lies behind the design is effective. By understanding its concept and learning the designer's way of thinking from it, you will be able to add your originality and present a new expression.

辦不到
的事

📷 就設法

✏ 發包

📄 出去吧

Outsource things that
you can't do yourself

以較少人數經營公司時，或許無法事事自行處理，因此與其讓員工
執行不熟悉的工作，還不如發包給平常委託的專業團隊負責，更能
快速做好高完成度的工作。

You won't be able do everything in-house if you're running a compact
firm with a small team on staff. Rather than making your staff handle
tasks that they're unfamiliar with, being able to draw on the resources
of a professional team outside your firm will enable you to deliver
high-quality work at short notice.

チャッ

要努力增加

Increase your fan base

最近和「我會這件事、也會那件事！」相比，「那個人好像會這件事、也會那件事」則更具有說服力。事實上你的評價的確不是來自自己，而是來自他人，既然如此，就應努力增加更多會擅自幫你PR的粉絲。當然也別忘了替願意幫你宣傳的人做一番PR。

Self-advertising your manifold talents and skills has now become less credible than other people spreading the word around on your behalf. Your reputation is not self-made – it's based on how others evaluate your work. This means that you should try to build a wide fan base that will automatically do your PR for you. Of course, don't forget to return the favor to these folks.

成為
能創造出
價值
的人

Hold on to your own sense of value

藝術家森村泰昌曾說過：「不要受人所影響，應該去影響他人。」
如果覺得「什麼事都沒什麼大不了」，那麼最後就會「對每件事都
無感」。在所有的價值都不再具有價值，做任何事都是被許可的情
況下，到底還能做什麼樣具「冒險性」的選擇呢？這是世上所有在
追尋價值的人所應解決的課題。要創造出新的價值，就必須在必要
時大大逆轉自己的思維。

The artist Yasumasa Morimura once said that "influence is not some-
thing you are subject to, but rather something you exert." If anything
goes, then nothing has any impact or significance. In a world where all
values have become flat and anything is permitted, what are you going
to "risk" choosing? That's the task demanded of those who've taken it
upon themselves to question the values of this world. In order to create
new values, you're going to need a major shift in consciousness at some
point.

在腦海裡建構印象

Construct an image in the
mind of the viewer

好的簡報方式能瞬間在對方腦海裡建構出印象，並深深留下殘影。
只要活用語言和圖片，就能在對方腦裡描繪出鮮明的印象與創意，
而只要這些印象與創意的解析度夠高，就能產生共鳴（sympathy），
並鞏固信賴關係。相反的，如果連自己人都無法產生共鳴，就不可
能在外人的腦裡建構出印象，這就表示不該推出這種印象或創意。
只要能在他人腦裡留下殘影，表示設計的第一階段已經成功了。

A good presentation creates momentary images in the mind of the
viewer, leaving a clear and sharp imprint. You can trace images and
ideas vividly in the mind of the other person using words and pictures.
The higher the resolution of those images, the more sympathy you'll
be able to elicit, and the more solid your relationship will become.
Conversely, things that can't even strike a chord with your own staff are
obviously not going to resonate with other people – not at all the sort
of work you'd unleash on the world, is it? If you manage to leave an
imprint on someone's mind, you've nailed the first step of the design
process.

讓工作順利的完成吧

Wrap up the job with flair

工作到最後階段時，應製造機會與客戶共同回顧過去的整個設計過程，才能讓整個設計專案，真正朝向完成的道路前進。設法讓客戶持續深愛整個設計內容，才是設計師最後真正的工作，也是最大的工作。另外，不在現場留下非必要的設計痕跡，也同樣很重要，一定要巧妙完成最後工作，好朝向下一個工作前進。

At the very last stage of a project, create opportunities to look back on the design process together with your client. This takes the design to its real conclusion. The designer's final – and most daunting – task is to make sure the client takes the effort to continue to develop an emotional attachment to the design. It's also important to ensure that the designer doesn't leave his or her mark on the site.

讓自己的 時間 得到更高的 價值

Set a high value for your own time

不同於只要推出暢銷產品，就能大賺一筆的買賣業，設計業是屬於委託式的行業，因此唯一的資源就是自己的時間。只要當自己的時間全都排滿工作，就無法接受新的工作，而且因為相同的工作也不可能遇到第二次委託，所以不必每接到一個工作就推出全新的設計，這樣工作起來會沒有效率。為了讓自己的時間得到更高的價值，只能在短時間內準備好具高價值的設計案；一定要集中火力在這一點上。

Unlike businesses that create limitless revenue when something makes a big hit, your time is the only resource for the design contract work. You cannot accept an offer when your available time is exceeded. Furthermore, since the same work is never offered twice, designing is an inefficient process because you must create a new design every time. The only way to set a high price for your time is to create a design with high value in a short amount of time. Concentrate on that.

擁有
自己的語言

Hone a language that is your own

要讓他人理解你所思考的事，必須隨時做好準備，明白用哪種語言才能有效傳達重點。有能力掌握對事物感覺的人，遣詞用語也會很細膩。無法確實與人對話的人，很難有好的設計作品，因此平日就要隨時鍛鍊自己的語彙，設法以更好的語言說明自己的設計，為了讓各式各樣的人理解你的無形魅力，這也是身為提供驚喜的人所應做的努力。

Always prepare yourself to know in advance which words you're going to use in relation to which point, so that other people can understand how you think. People who are good at reading and latching onto the sensations associated with certain things also have a delicate touch when it comes to language. Good design tends to be beyond the reach of inarticulate people. Work on acquiring a vocabulary that allows you to always explain verbally why something is good. This is the effort that the supplier needs to make, so that as many people as possible understand the intangible appeal of one design compared to another.

103

安排 不在的日子

Make time for days when the boss isn't around

老闆不見得隨時都會下達明確的指示，這種時候必須各自隨機應變，而當指揮系統不存在時，則更能看出組織的真正力量，所以偶爾應刻意安排老闆不在的狀態。平常就設置能暫代老闆位置的中間管理職，以測試這個人身為最高主管時的管理能力。

There are not precise instructions from a boss, and each person must always think for adaptation to circumstances in such case. The true ability of the organization is reflected on movement when instructions system does not exist. I will occasionally make a state of the boss absence daringly. I put middle management in the temporary boss position, and it is important that I try an ability.

從殘影裡
找出小小的黑點

Look for the little black dots in the afterimage

工廠裡的歐巴桑表情一動也不動的直盯著前方看，因為大量排列在輸送帶上的汽車標誌，速度飛快的經過她眼前，她必須在瞬間裡找出有刮痕或髒汙的不良產品，並立刻拿走。此時的她並非一片片的檢查，而是找出眼睛殘影裡的小小異物，就像不斷反覆同樣的事之後，自然能清楚看到小小的問題點一樣。這種「似乎和平常不太一樣!?」的感覺很重要。

The lady who works in the factory looks straight ahead without moving her face one bit. The endless rows of car emblems on the conveyor belt whiz past her at an incredible speed. It's her job to find defective emblems with scratches or stains on them, and pull them from the belt right away. But she doesn't do the job by looking at the emblems one by one – what she's really doing is stariing past them, at the little irregularities in the afterimage of all those objects. By doing this repeatedly, she becomes able to detect all the small problems. Different from the usual – this is important.

只要沒有

完全瓦解 就行了

We're fine as long as we don't completely collapse

從事設計或製造物品的公司，經常會工作到很晚，甚至常常通宵，讓許多原本懷抱夢想與期望而踏進這一行的人，因為承受不了現實的考驗而辭職，這也是這個行業的特徵。要讓公司變得更好，其中一個方法當然是改善工作環境，不過這個行業的另一大特徵就是經常在徵人，既然如此，或許就該擁有「即使有人辭職，只要不會造成整個組織瓦解就行」的心態。

Design and manufacturing companies tend to have a culture of working late into the night, with frequent all-nighters. Another thing that's unique about this field: the many youngsters who join design firms filled with hopes and dreams, only to quit after realizing that they can't deal with the harsh reality of the industry. One way to deal with this problem is to improve working conditions in order to become a better company, but the constant search for staff is another thing that's particular about the design field. Perhaps a better attitude to have is "even if people quit, we're OK as long as we don't fall apart as an organization."

追求簡單到極致

Refine simple things

「簡單」並不等於「容易又低成本」，而且往往是相反的，一定要深思熟慮。追求簡單到極致的意思，就是要整理所有被包含其中的複雜性，然後給予順序，以省去無謂浪費，甚至為消弭自我的存在而做出最大努力。唯有從無數檢討過程中所誕生的設計才有價值，而反覆這種經驗才能創造出品牌，為了達成這個目標，也需要將自己時間和金錢大量的投入其中。

"Simple" doesn't mean easy and low-cost – the opposite, rather. Simple things require you to mull over them. The act of refining simple things demands an incredible effort to sift through all the complexities that they entail, rank them, eliminate the extraneous – and even a sense of itself as an object. The sole value of design lies in the countless investigative and analytic processes that it involves, and a brand is what emerges from repeated iterations of these processes. That's why design requires an overwhelming self-investment in terms of both time and money.

為他人著想

Work with someone in mind

無法幫助人的工作不能稱為設計，好的設計應該為他人著想，就結果而言也等於是為了自己。不過「為自己」只單純是最終的結果，絕不能以此為目的，這一點不僅是對客戶如此，在主管或師父底下擔任新手設計師進行工作時，也同樣應遵守這個原則。

Work that doesn't have a particular audience in mind can't be called "design". Good design serves the needs of people, and ultimately becomes something you produce for the sake of yourself. This act of working for yourself is really a kind of end result – it can't be an objective in and of itself. This applies not only to your clients, but also to budding designers who spend a period of time working under their superiors or more senior figures.

Nod 點頭示意

日本人的習性無意識的「點頭示意」，雖然對方並非笨蛋，非常明白你點頭示意代表什麼意思，不過這種頻繁的點頭示意反應，還是能帶給對方良好的印象。因為一般來說，沒有人會因對方的點頭示意不具太大意義，就對對方產生不信任感。

Nodding – that most Japanses of habits. The other person is no idiot, you know. He can tell what you're thinking when you nod at him. On the other hand, nodding also tells him that you're reacting to everything he says and does, which ought to give him a good impression of you. There aren't too many people who would distrust someone who nods without good reason.

設 計

是屬於誰的
應該想清楚

Whose design is it?

不論你完成多棒的設計案，如果對使用該設計或感受該設計的人來說，是無法接受的內容，那就毫無意義。設計到底屬於誰的？只要能想清楚這一點，就完成了 50％的設計。

No matter how great a design you manage to come up with, it's not going to mean anything if the end users who will actually interact with the product are going to find it unwieldy. Who are we designing for? If you can answer that, half the battle is won.

設計
設計
DESIGN

要努力滿足他人

Satisfy others with your design

設計這種工作，必須滿足他人才會具有價值。說實在的，要創作出
能滿足自己的設計其實很簡單，但實際上卻應該站在他人的立場來
批評自己的創意，並從中一邊改變形態一邊努力往上爬，這樣的設
計才叫設計。至於出示你的設計給他人看，可算是一種娛樂表演，
所以不論是小小的討論會，還是大規模的簡報，都要設法提出超越
客戶期待與想像的內容。

Design work has value only when the designs satisfy other people. It's
actually easy to create self-satisfactory desings. Review your idea from
the other person's perspective and criticize it. Though they change
in form, designs that tenaciously surivie this are the genuine ones. In
addition, a design presentation is a form of entertainment. Regardless
of it's a small meeting or a large-scale presentation, you should always
present outputs that exceed the clients' expectations and imagination.

119

拍
攝
出好照片

Take good photos

對設計師來說,沒有比照片更好行銷的工具,因為媒體都喜歡以美麗的照片為封面,所以無法看到實際物體的國外雜誌作家,都會以電子郵件的附檔照片為依據來撰寫文章。此外,要競爭設計獎或參加比賽時,附上照片一起投稿,同樣能獲得極大的效果。當然也別忘了附上設計師本身的照片,最好準備一張能給人留下深刻印象的照片,以奠定你的公眾形象。

Photography is the best marketing tool that a designer can possibly have. Magazines love to have nice photos within their pages, and correspondents for international publications who don't have access to the real thing will write articles based on photos attached to your emails. Photos also play a key role when applying for design awards and submittion work to competitions. Make sure you have a proper portrait taken, too – it's your public image we're talking about, so you'd better have a picture that will make an impression.

No.1 Takahiro

No.52 Hitoshi

不給混水摸**魚**的機會

Always keep one
eye on your staff

對於部屬所做的事要完全掌控，從不給混水摸魚的機會，只要一有人摸魚就要發怒，彷彿隨時都在監視部屬一樣。但實際上要一整天都認真面對某一個人，往往只要一小時就會受不了了，而且其餘的時間也很難能和對方有共識，因此我都會認真面對對方至少一小時，因為如果連這短短的相處時間，都任由對方隨性而為的話，幾乎就無法和對方共有任何事物了。

Don't let anything your staff do pass you by, but also make sure you don't leave them entirely to their own devices. Get mad at every single thing they do, to the point where they feel like they're under constant surveillance. Keeping a serious eye on one person for one hour in one day, however, should be as far as it goes. The rest of the time, you won't even be able to be conscious of each other's existence. Make sure that you have at least one hour of serious face time. You won't get anywhere if you let even the amount of face time with your staff take its own course.

試著和
異文化
溝通吧

Participate in cross-cultural
communication

如果要到海外工作，只要擁有能與人溝通想法的活力，基本上就不
會有太大的問題。比手畫腳、筆談，什麼方法都可以採用，畢竟對
方想要的是好的設計案，而不是設計師的外語能力，要是對方覺得
有必要，自然會主動聘請口譯人員幫忙。不過能以自己的語言表達
出來，才是最精準又令人舒暢的事，所以應該擁有這種動力，才能
消弭溝通上的問題。

If you have the energy to communicate, working overseas is unexpect-
edly easy. There are many ways to communicate, such as with gestures
or writing. Clients just want splendid designs, and don't care about test-
ing the designer's language skills. If necessary, they will bring an inter-
preter. However, communicating in your own words is more accurate
and is more satisfying. When such motivation arises, communication
problems are mostly solved.

到 海外 去 工作

Work overseas, too

可以的話別只以日本的 1 億 3,000 萬人口為對象，應該以全球的
70 億人口為目標來製造產品。簡單的說，就是以全世界為目標，因
為設計業是一個無止盡的行業，世界上存在有多少文化與哲學，就
有多少設計案可以推。設計本身擁有很強大的說明力，因此語言的
差異並不重要，即使溝通上有外語能力不足的情形，也可以用熱情
和才能來補足。

If it's something that's within your reach, don't just make things that
target the 130 million people in Japan, but the 7 billion people around
the world as well. The field of design is limitless. There are as many
answers and solutions to design issues as there are cultures and ways of
thinking in this world. Design can speak eloquently for itself, so differ-
ences in language aren't really an issue. Communication that is lacking
in linguistic terms can be made up for through passion and talent.

不要過度意識到自己是日本人

Do not have an
over-eagerness to be Japanese

雖然俗話說「入境隨俗」，但以設計業來說最好不要隨俗，因為對方是看上你是「日本設計師」才會委託你工作的，所以只要就你最拿手的設計，稍微改變一下呈現方式，對方應該就會很開心。不過別時時意識到「日本」會比較好，因為在你的設計裡，早已下意識加入了日本人特有的氣質，這一點是你無法逃避的。

Although the expression goes "when in Rome, do as the Romans do", it is better to not follow this dictum in design work, since the client offered you the job because they considered you a "Japanese designer". If you show them a design that you are good at, which has been slightly modified to make it easier for then to understand, they should be happy. Furthermore, don't be conscious of Japan. Your designs are unconsciously Japanese-like, and cannot escape that fact.

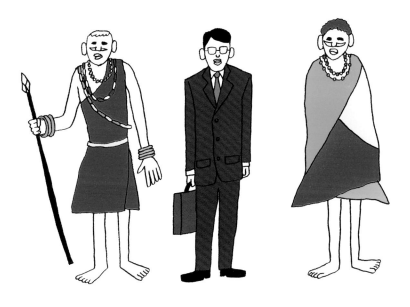

擁有

雙重人格

Have a double personality

要擁有阿宅的一面與非阿宅的一面,因為在醉心於專業領域的同時,若能兼容有專業外的主軸觀念,就能培養出客觀性。如果只擁有單方面的主軸觀念,很容易會變成純為嗜好、而非工作。

Cultivate both the nerdy and non-nerdy aspects of your personality. Get an objective view on things by having access to references outside your field of expertise, even as you remain committed to your specialty. If you only have one or the other, you run a high risk of remaining a hobbyist, not a professional.

MYSTERY!

DR. JEKYLL & MR. HYDE

思考「單一文字」所能烙下的印象

Think hard about the impact
that single word will make

既然是設計師，或許連附信裡的單一文字，都必須思考它可能會帶給對方什麼樣的印象，因為從日常使用的信封與附信等文具用品到網頁，所有對外的訊息都代表公司的形象。

Designers ought to think hard about the impression that even a single word in a particular font on your cover letter will make on the recipient. Every object bearing your name that goes out into the world – from the envelopes, letterheads and other stationery that you use on daily basis to your website – is the public face of your company.

neoplus610

STANDARD TRADE.

渡邉 謙一郎

TRANSISTOR

木村 茂

試著將 對方的 觀點 以視覺方式 來想像看看

Visualize things from the
other person's perspective

物品與空間,看在他人的眼裡會是什麼情形?許多時候唯有站在對
方的觀點來確認,才能看到許多事實。

How do other people look at objects and spaces? Lots of things be-
come obvious when you actually put yourself in someone else's shoes
and verify this for yourself.

工作累了一定要 休息

Take a break if you're tired

儘管休息沒關係，因為休息是一種權利，它能帶給你彈性處理工作的能力。不過此時別坐在辦公桌前看電腦喝茶，淨做些無謂的事，應該到外面去踢踢足球或買東西，甚至也可以去喝一杯，給自己一點自由的時間。就算周遭的空氣不太允許你這麼做，相信老闆應該也會為了提高你彈性處理工作的能力而體諒你。

It's important to take a break. Time away from work is a right, and it helps to take the edge off a bit. It's not a cop out to have some tea while surfing the internet at your desk. You should even feel free to go out and play some soccer, do some shopping, or have a drink. Even if it feels like you're slacking off, your boss ought to be fine with that.

聯結創作者與使用者

Connect creators with users

產品最終會落到需要的人手上，但並非所有產品都是直接受到使用者的委託而製作的。例如一次就會製造某種數量的產品，通常中間都會經過幾個業者之手後，才輾轉送到使用者手上，而這些中間商不論是商社或店鋪，都需要容易販賣的產品或設計，因此必須是以讓這些人容易說明產品優點的方式設計才行。

Products ultimately end up in the hands of the people who require them, but not all of them are made in response to a direct order from the end users. Products that can be manufactured in considerable quantities generally pass through the hands of several middlemen before reaching the user. These middlemen can be trading firms or individual shops, but the products they handle need to sell easily, or have designs that paaeal readily to customers. In general, these people are "designed" in a way that allows them to expound on the merits of a particular product.

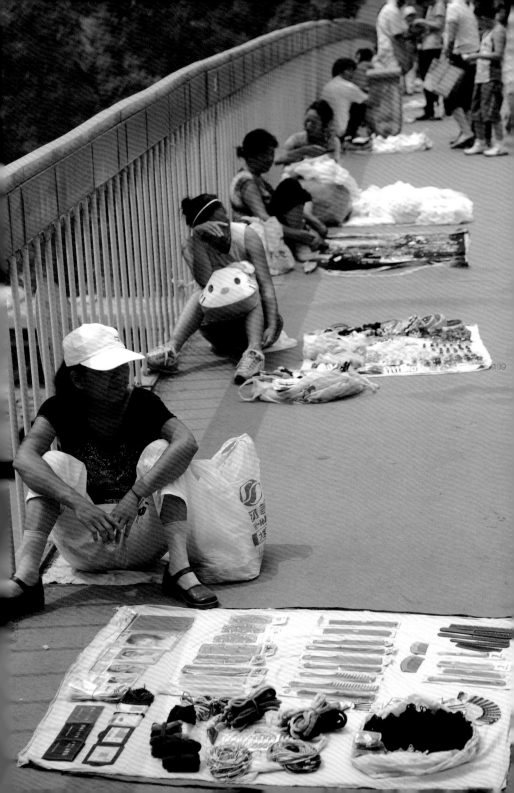

Analyze your own position
and capitalize on it

雖然可以理解個人想自行創業的挑戰精神，但其實只要能穩居一人之下、眾人之上的位置，就和自行創業沒兩樣。第二名也沒什麼不好，就像足球選手中村俊輔一樣，適合自己發揮才能的地方，不見得一定都在最受注目之處，您必須了解還有一個位置是能驅使上位者採取行動的。

It's natural that you want to take on all these challenges by yourself, but the position just behind the striker is also an autonomous one. It's not such a bad thing to stay in the backseat. The frontline isn't the only place where you can make the best of your talents – just like the soccer player Shunsuke Nakamura. The task of supporting the front man is also an important one.

情報

為了發揮實力要對

抱持著敏銳度

Perk your ears up to information
that will make the most of your abilities

或許只要花時間就能有好成果也說不定，但愈是沒時間，就愈能看
出你的實力何在。要培養實力，必須快速察覺日常生活裡從眼睛與
耳朵所得來的情報資訊，例如從住家走到車站時，途中有些什麼東
西？或許有許多商店、公司、人們，而這裡面充滿了各種提示。就
連平日新聞，是否都能當成你自己的事在理解？一定要貪婪的吸收
所有情報資訊。

Maybe you'll come up with something amazing if you just invest the
time, but it's only when you're pressed for time that your skills are re-
ally put to the test. In order to cultivate these skills, it's also important
to quickly pick up on any snippets of information that might cross your
path over the course of your daily routine. All the shops and restau-
rants, offices, and people on the journey from your home to the train
station, for instance, are rich sources of clues and hints ripe for the
picking. Are you taking in the news for the day by seeing how it relates
to you personally? Make sure you greedily absorb everything around
you with a passion.

聽聽
親近
的
人
的說法

Ask someone nearby

最瞭解自己的家人，就是最嚴厲的批評者，所以應盡量讓他們對你的設計態度與思考方式提出批評。家人能提出外行人的客觀看法，也會站在共同承擔家計的立場上來提供意見，這都是幫助你重新檢視自己的設計與商業感的好機會。此外，在設計案有了大致雛型時，不妨假裝家人或情人就在眼前，想像自己對他們解說的樣子，確認自己是否能順利傳達。非常推薦這種方法，因為這能有效的幫助你解開僵化的思緒，以重新檢視設計案。

Your family knows your ture self and they are your bitterest critics. Ask for their opinions about your attitude towards design or way of thinking. Opinions with objective perspectives from the general public or from someone who you live with provide good opportunities to reconsider your designs or business sense. Also, when you are at a point where your design idea is roughly taking shape, imagine yourself explaining it to your family or lover. Can you explain it well? This is a recommended method for reviewing your idea with a relaxed state of mind.

成為　Become a cupid
愛神 ✄ 邱比特

試著將可能引發化學反應的人們湊合在一起，就算只提供場地也
OK，不過記得選在沒有所謂利害關係的場所進行。只要反覆這麼做，
就能逐漸架起「設計之橋」。

Try to connect people who might have interesting chemistry together.
All you need to do is provide a place where they can meet. Of course,
don't think about what you stand to gain or lose by this matchmaking
process. Before you know it, you've managed to "design" yourself a po-
sition as a kind of mediator or middleman.

試著 轉換成 文字敘述 來進行

Put it in words

有時面對工作對象時，會以某些抽象的文字來貼近情境，例如拍攝
照片工作時，以「捕捉黑暗」的抽象文字進行活動，就有可能在黑
暗中製造出色階或深淺度，甚至是採取長時間曝光等各種手法。將
照片化為文字，然後再度化為照片。

One possible working approach is to come up with a provisional term
or phrase to describe it. For instance, trying to "capture darkness"
during a photo shoot. This will inspire various approaches inspired by
the gradations that exist within black, a sensation of depth, or the time
involved in long exposures. Take a photo, express it in words, and then
take the photo again.

找出
看起來
最美的
狀態

Look out for things at their most beautiful

就像馬桶座在蓋上蓋子時的狀態最好看一樣，所有東西都有它最美的狀態，一定要設法在各種場合裡尋找並實踐這一點。負責將美麗的東西送給世人的人，一定要在上完廁所後，蓋上馬桶座的蓋子。

A western-style toilet looks most beautiful when the cover is closed. All objects in this world have an ideal state that makes them look their best. As a designer, never forget that it's your job to keep searching for and implementing these situations wherever you can find them. Those whose role it is to bring things of beauty into this world should always remember to close the lid on the toilet after you finish your business.

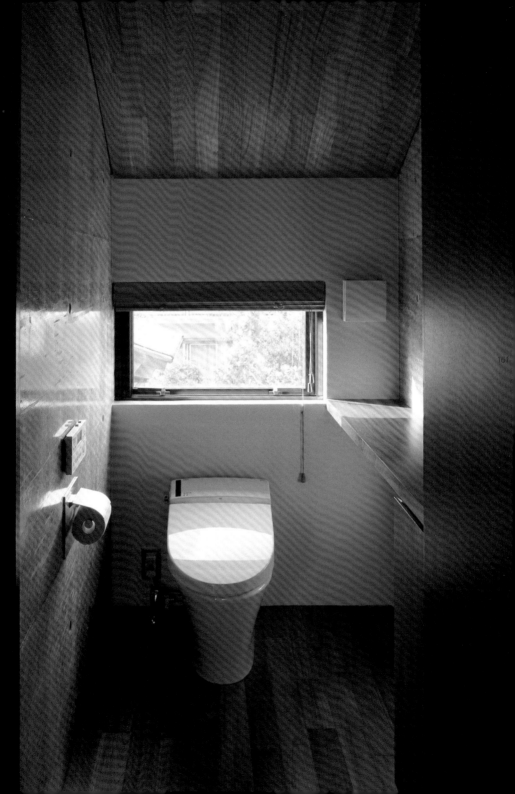

試著相信實際的感覺

Trust your gut feeling

不要以業界的習慣來決定，應該以自己從經驗裡培養出來的實際感覺來決定，即使是很沒有常識的事，也一定要相信自己的實際感覺，才能算出精準的需求與風險。最值得相信的，就是自己實際的感覺。

Decisions should be made by ignoring industry conventions and relying on gut feelings that are acquired through your own experiences. Even if it lacks common sense, you can only calculate realistic hopes and risks through your gut feelings. The most reliable thing is your gut feeling.

打招呼 也是
設計的一環

Greetings are design, too

見到人時，會從打招呼開始，也會以打招呼做結束。以敝公司的規定來說，只要有客戶來訪，不論大家手上正在做什麼事，都一定要先停下手來向客戶打聲招呼。不打招呼表示對客戶欠缺敬意，在這種情況下是不可能想出好的設計案，因為打招呼表示「這是屬於你的時間，我們會以你為主提供服務」，也是設計應有的態度。

Meeting someone begins and ends with a formality or greeting. One of the rules at our firm stipulates that all staff leave their work, no matter what they may be in the middle of doing, and greet visitors who've arrived at the office. Not greeting visitors shows a lack of respect for these people, which will never lead to good design. Greetings tell other people that you provide a service at their own time, pace, and convenience.

一日之計

在於

早餐

The key to a successful
day is breakfast

生活的基礎在於健康管理，尤其是自由工作者，生活往往不規律，
應該停下腳步好好思考，通宵工作或工作到深夜，是否真有效率？
其實早起並確實攝取早餐，才有辦法在積極的態度下，展開全新的
一天，因此絕對要利用早餐來調整生活與工作規律。

Keeping in good shape is the foundation of life. Freelancers tend to
have irregular schedules. Stop and think about the efficiency of work-
ing all night or late at night. By waking up early and eating breakfast,
you can start the day in a positive manner. Regulate your life and work
rhythms by having breakfast.

應以 客戶 為本位

Be customer-driven

「以客戶為本位」絕不是要「事事迎合客戶」，而是從「非以自己為本位」的態度來展開工作，這也是設計的基本態度。不論想出多完美的設計，若無法被人所接受，就只是一相情願的想法，嚴格來說並不能稱為設計。在創作的同時必須感受對方的存在，才是最重要的事，因為唯有活在日常生活裡，才能創作出真正的設計。

Obviously, "customer-driven" doesn't mean that you should be ingratiation. On the other hand, avoid striking out on your own at all costs when it comes to design. No matter how wonderful your design is, if it's just a one-way thing and not accepted ty other people, you can't call it "design" in the strict sense. Make sure to create things with your client or end user in mind. Design comes about by living in the real world.

刻意組成

的團隊

以
年輕人
為主

WAKATE

Create teams of mostly young people

如果是經營者或資深員工，因為累積了一定程度的經驗，也有豐富的知識，所以比較不會失敗，也能留下成果。但相對來說，也容易受到過去的成功經驗束縛，對於挑戰新事物會顯得興趣缺缺。因此不妨組成以年輕人為主的團隊，讓年輕人負責某些專案，尤其是早已奠定基礎的事業，不妨放手讓他們試試看，或許你會發現，這些基礎事業能因而維持更長久，畢竟一成不變是最大的敵人。

Thanks to eheir previous experience, managers and veteran staff members may be able to deliver solid results with few mistakes by putting their extensive knowledge to use. But they tend to stick to their previous successes, and may not have the inclination to take on a new challenge. So maybe it's a good idea to deal with certain projects using a team made up entirely of younger staff. This is particularly true if the mainstay of your business is in good shape – you should just try leaving it to the youngsters. This way, your core business might even prosper longer. The worst fate of all is to get stuck in a predictable routine.

Become a mother figure 成為 母親

女性與其以工作為職志，最好還是能經歷過一次為人母的經驗會比較理想，因為擁有不同的世界，能從中學會如何取得平衡，何況設計本來就是與生活有密切關係的工作，擁有愈多不同的面相愈有幫助，加上媽媽特有的溫柔與強大都是很偉大的要素，只要帶著這些要素工作，不論面對哪種場面，都將有辦法克服過去。

Instead of devoting yourself wholeheartedly to your work, what women really want is for you to try and see what it's like being a mother. Becoming a mother gives you a fine balance between various elements because you have access to different worlds, and design bears an intimate relationship to life itself, so being attuned to different "channels" and wavelengths goes a long way. The tenderness and strength of a mother are noble qualities to have, as well. If you can tackle your work with these traits on your side, you shouldn't have a problem dealing with even the toughest of situations.

要多PR

Sell those stories

設計師應將智慧與創造力全部貫注在故事的 PR 上，而且必須持續進行一段期間，因為只要看過愈多的宣傳愈會發現，「設計的呈現手法」非常重要，而這些要素的整體表現，就稱為品牌。一定要藉由自己的設計，持續觀察他人對你的評價，尤其是關鍵人物所提出的建議或批評，絕對都能反映在設計上，一定要努力維持長久的人際往來關係。

Designers ought to devote their knowledge and creativity to launching PR campaigns that will durm up public interest in stories, in a continuous way for a fixed period of time. Dealing with lots of press and media people will make you realize the importance of how design is seen and regarded. All these things are expressed in the form of a brand. Keep an eye on public opinion through your own designs. Advice, feedback, and appraisals from the key players in the industry will definitely been reflected in your design work, so a long and lasting relationship with them is essential.

試著設計

餐會

Design the meals you have together

餐會也是設計的一環,因此與客戶用餐時,應極力避免提及工作的事。因為餐會是彼此瞭解對方是什麼人的試煉會,一定要避免以商業態度來接觸對方。只要用餐中能取得良好溝通,餐後的會議通常就會很順利。客戶會與我們聚餐,表示他正打算與我們建立起信賴關係。

Food is design. Make sure you don't talk about work whenever you have dinner with your clients. These occasions are when you're trying your best to find out more about each other as individuals, so leave your business persona at the door. If you can have a lively conversation during the meal, the meeting that follows will typically go well. Your clients are having a meal with you as a preliminary step to entrusting their concerns to you.

不要保持

沉 默

Don't keep

silent

開會時一定要弄清楚目的是要得出結論，還是在於彼此的討論。如果目的是要得出結論，就開到有結論為止，若目的只是要討論，就訂定規則不准保持沉默。有些人會以「我正在思考」為藉口，什麼意見都不說，但其實通常這種時候，不是腦裡根本什麼也沒在想，就是沒有勇氣提出發言。一定要利用開會來鍛鍊自己的瞬間爆發力。

Hold meetings with clear objectives – are we here to reach some kind of conclusion, or talk things over? If it's the former, don't end the meeting until you reach the conclusion. If the latter, make sure nobody stays silent on the matter. Some people are going to refuse to contribute and say "I'm still thinking about it", but most of the time they haven't thought about it al all. Use these sessions as opportunities to train your staff to perform when put in a tight spot.

非特定多數就不發送訊息

Address a specific audience

設計業並不是量產的製造業，而是以特定對象為主的服務業，所以不該對不特定的多數人發送訊息。就結果來說，這種行為能成為過濾器，幫助你得到較好的工作。

A niche service that is not a mass product shouldn't speak to a general audience. The nature of your work ultimately serves as a filter, and gets you the choicest jobs.

試著驗證

獨創性

Verify originality

因為資訊與流行情報都會自然而然的被輸入腦裡，所以就算你想到很好的設計靈感，仍有可能是其他設計師早就想到的陳腐創意。要確認該設計靈感是否具有獨創性，應從各種不同的角度來驗證，唯有具獨創性的設計，才有可能長存下去。

Information and trends are naturally absorbed by your mind. Even when you come up with a wonderful idea, it is highly likely that the idea has already been used by another designer and has become obsolete. It's important to verify from all sides to see if the design has originality. Only designs with originality can endure for the long term.

工作應具備美感

Make beautiful work

完成度高的工作總是「美」。不只是設計與藝術的世界，不論哪種
工作都一樣，完成度高的工作，就是美。

Highly polished work is beautiful. This applies to all sorts of work, not
just the world of art and design.

和一起工作的人維持好交情

Become friendly with those you work with

只要和一起工作的人維持好交情，就一定能完成好工作，相反的，若不夠瞭解對方而持續一起工作，很容易引起糾紛。要建立好交情需要一段時間，要失去信任卻是一瞬間的事。多花時間從培養人與人之間的交情做起，也是設計的一環。

If you can become friendly with those you work with, you'll definitely be able to produce good work. Conversely, you're going to run into problems if you keep working without understanding these people at a personal level. While it takes time to get friendly with someone, you can lose someone's trust in a single instant. Design entails investing that extra bit of time to create interpersonal relationships from which your work will emerge.

在約定時間的

10 🕙 分鐘前

就 先 到 場

Arrive 10 minutes ahead of time

先掌控會議或簡報會場的氛圍，有時能產生意想不到的創意，成為當天可用的王牌，或看清楚原本沒看到的問題。要是遲到進場，就只能從謝罪的語言開始展開對話，一定要避免發生這種情形。

Never misjudge the appropriate scale of the organization required to maintain the quality of your work. The moment the number of staff exceeds a certain limit, the standard of their work is going to nosedive. In order to maintain the quality of work expected, you need to find an ideal size and scale for your organization that corresponds with the content of the work and the abilities of your managers.

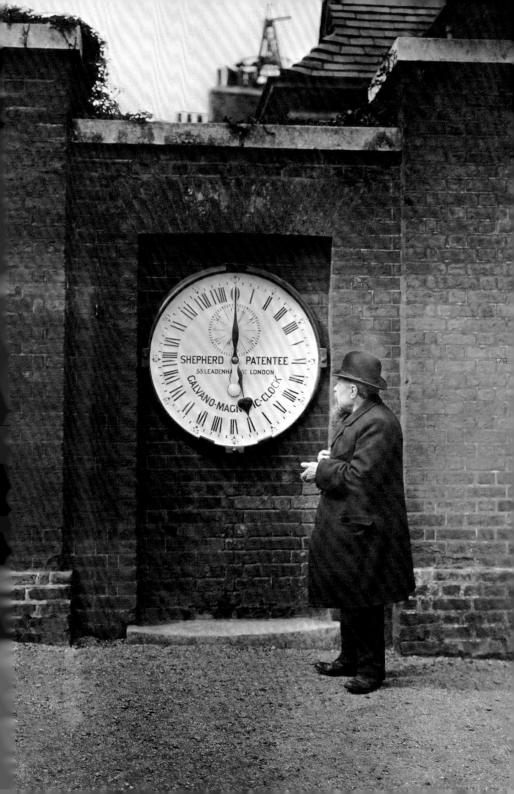

取得粗細之間的平衡

Strike a balance
between the coarse and fine

最近的消費者只買真正需要的東西，尤其是紙張類書籍的狀況尤為
顯著，因此除了內容必須紮實外，就連設計上也得突顯「看起來就
很有幫助的樣子」，導致有愈來愈多人特地將封面製作成粗細混合
的感覺。粗的部分是指容易閱讀，看起來視覺舒服的內容＝淺顯易
懂，細的部分是指資訊量足夠＝看起來很有幫助。即使如此費心設
計，都還不見得一定能暢銷，這也是最困難的地方⋯⋯。

These days, consumers only buy what they absolutely need. This is even
truer when it comes to books, which are moving away from paper at
an alarming rate. Content now becomes a non-negotiable given, while
the design of these books needs to appear useful and functional. When
designing for paper, therefore, make sure you intentionally include a
blend of coarse and fine textures. The coarse parts are more legible
and make it easier for the eye to latch onto the text, emphasizing the
quality of the content. The fine print, so to speak, conveys the volume
of the information presented, and a sense of being functional and
helpful. Of course, this approach doesn't necessarily mean that the
title will sell…

思考

代替法

Find some other way

不是我愛自誇，我非常不擅長畫素描，所以從來不畫素描。也因為
很不擅長畫素描，所以每次看到實際的物品時，總覺得兩者差很大。
練習畫素描是一個不錯的方法，不過我採用的是另一個方法，就是
先畫出精準的圖面，再訓練自己想像實際完成後的模樣。採用這種
方法很花時間，也經常出錯，不過現在已經成為我的另一項技術，
並大量靈活運用。

It's kind of embarrassing, but I can't draw to save my life and so I never
make any sketches – or I do, but they always end up looking totally dif-
ferent from the real thing. Practicing how to sketch is one possible way
of doing things, but you decided on a different method. You made an
accurate diagram, and trained yourself to be able to envision the final
product. It ate up a lot of time and you made lots of mistakes, but now
you've acquired this skill that you can deploy in your work.

對不同的「8寺間6」抱持體諒

Pay attention to different forms of "time"

建造一幢建築物所需的長久時間、一切行動以截稿為首的編輯者時間、24 小時都得開機的老闆時間,日本與海外之間不僅有時差,也有不同時間的價值觀……一定要瞭解在商場上,存在各種與自己的時間流動方式不同的時間,對事業才有幫助。只要懂得體諒在不同時間體系裡工作的對方,就能順利維持彼此的關係,避免不必要的糾紛。

There's a time difference between Japan and other countries, of course. But what about value systems associated with different conceptions of time? The length of time it takes for a single building to be completed, for instance. The time of an editor with his mind always on his deadlines, or that of a boss who is always "on" twenty-four hours a day. When doing business, it helps to bear in mind that time flows in all sorts of ways, many of which obey a different rhythm to your own. If you respect the different paces at which each of your clients and projects operate – all of whom have their own conception of time – you'll be able to keep things going smoothly and avoid any unnecessary problems.

儘管抒發情緒

以傳達你真正的

♡聲

Let your emotions show

笑容當然很重要，但如果該說的話不直說，就無法傳達真正想傳達
的事。不論要道歉還是道謝，都別用電子郵件，應該面對面的直接
說出口。去看一場愛情電影吧！盡情哭泣、歡笑、生氣……好好發
洩你的情緒，甚至好好吵一架。當好人當然不是壞事，但永遠只會
是表面上的好人，最好還是彼此抒發自己的情緒，確實說出自己的
心聲，然後彼此反省，唯有如此，才有能力思考對方的想法。

It's important to smile, but you won't be able to make yourself under-
stood if you can't speak freely. Don't apologize or thank someone in an
email – express your feelings directly, in person. Shed tears, smile, get
mad, just like in a romantic movie. Let those emotions show. Quarrel
and argue. People who listen and empathize are nice, too – but they're
just "nice". You need to get to grips with other people, hold nothing
back, and then reflect on it. That way, you'll really understand how the
other person feels.

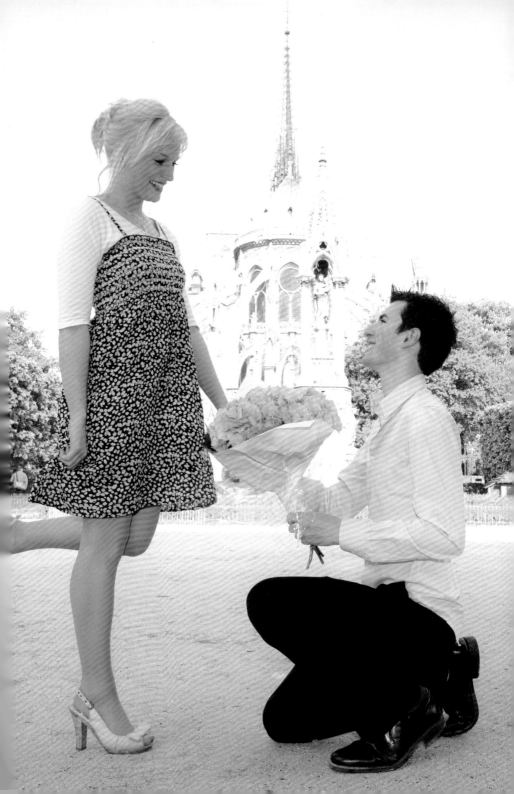

追 求 酷 70%

只能到70%

Stop at 70% for the cool factor

設計師總是很愛追求酷帥的要素，但對末端真正的使用者來說，往往不易理解設計的前衛性。若是為客戶量身訂做的產品，只要該客戶覺得滿意，就是好的設計。如果是量產的商品，就必須考量有些人具有高敏銳度，有些人感覺比較遲鈍，必須設計出多數人都能接受的產品，為此要產品化之前，必須先將酷帥要素控制在70%左右。換句話說，就是要讓稜角變得圓融。

Designers tend to always be on the lookout for cool stuff. For end users, though, many of the more innovative aspects of design can be tough to get a hold on. Custom-made products can be said to be well designed as long as the client is satisfied, but products made for a mass market need to appeal to all sorts of people – both connoisseurs with refined tastes and sensibilities, and people who are completely insensitive to design. In order to turn an idea into a viable product, you need to make sure that it's "only" 70% cool. This often involves softening the "edginess" of the product, so to speak.

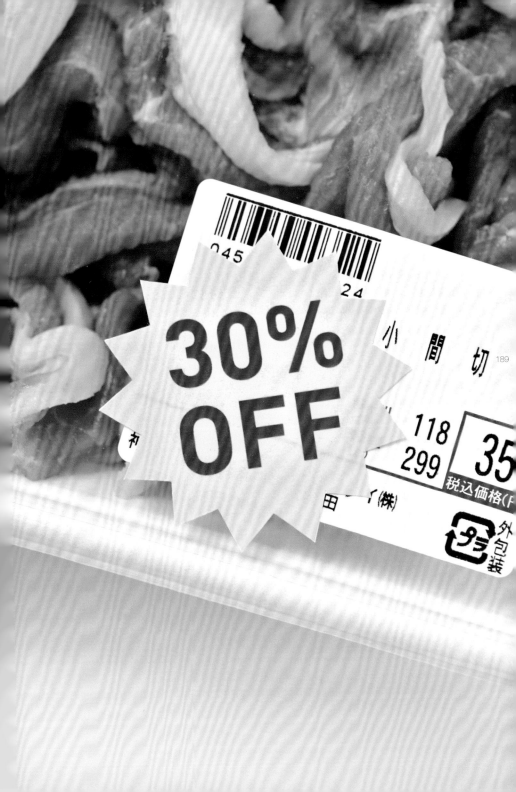

讓
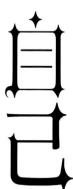
自己

更顯美麗

Make yourself look good

漂亮真是一件美好的事，所以不要疏於美容，不論活到幾歲都應追
求美麗。讓自己看起來很美，這絕對是有益無害吧！

Everyone likes attractive people. Don't skimp on that beauty regimen –
make an effort to look good no matter how old you are. It never hurts
to look attractive.

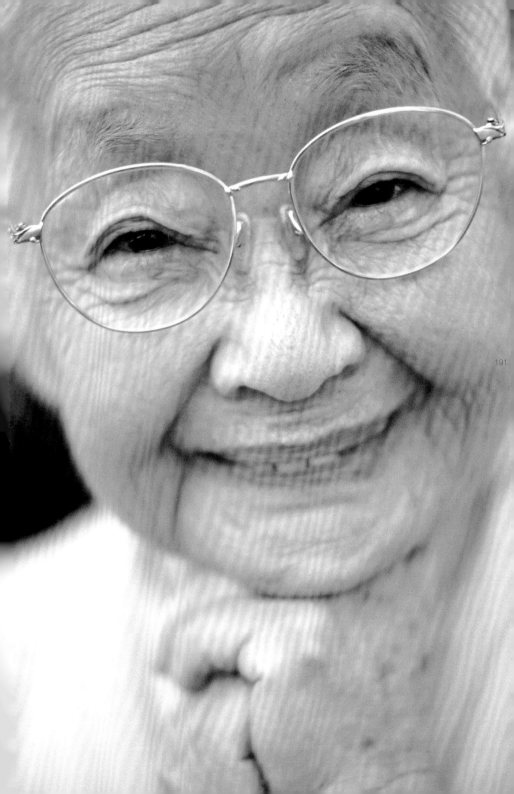

工作 讓 { 社會 與 我 } 聯 結 在 一 起

Work is something that brings you closer to society

一想到「要是沒了工作就會感到不安」的要素之一首推金錢，但並不是只要有錢進帳，就什麼工作都無所謂。想要和社會有著何種聯結？而如果真能以該方式聯結，並成為你的工作，那才是最理想的方式。工作就是不論奉獻給他人的時間長短，最終能回饋到自己身上，讓自己感受到生存的價值。

Money is one of the main reasons why people become anxious about having no work to do. But it doesn't mean that anything goes as long as you have the money. Ultimately, the goal is to do work that addresses the question of how you want to be involved in society, and the specific things that you can accomplish. Work is about dedicating your time to other people. The strengths and weaknesses associated with that time will be returned to you in kind – a sort of karma or payback.

2017　　　2016　　　2015　　　2014　　　2013

| |

的情形　　再稍微久一點之後　　In 3 years ◀┈┈┈┈┈┈┈┈┈┈┈┈┈┈　預想比現在能做的事

Think about
overreaching a little bit

剛成為社會新鮮人時，即使有很好的創意，也很少有人擁有人脈，以及足以實現夢想的金錢。現在很想做的事，有時得 3 年後才有辦法實現，所以應冷靜下來思考自己目前所處的狀況，再慢慢培養實力挑戰看看，唯有腳踏實地的累積，才能順利邁向下一步。

Even if people have a wonderful idea right after beginning their career, they usually lack personal connectios and money to realize the idea. The idea you want to work on now might be realized after three years. So, calmly consider the situation you are in, and then challenge yourself with things that are a little bit out-of-reach. The layers of such challenges lead you to the next step.

name 先決定名稱！

Decide on a name first

決定負責的專案小組後，首先應做的事就是為自己的小組取名！連自己小組的名稱都無法決定的人，很難有美好的未來。決定小組名稱還能增進彼此之間的感情與責任感，更重要的是成員們之間的動力，會出現戲劇性的變化。

Once you get your project team up and running, your first priority should be to pick a name. A team that can't even decide what to call themselves doesn't have a very bright future ahead of them. Choosing a team name will bring members together and make them take responsibility for the task, dramatically lifting the spirits of your team members.

試著
攻其不備

Launch a sneak attack

從約見面的地點移動到討論的地點，這中間短短的移動時間，以及在討論的地點裡坐下來，等茶水被端出來之前的短暫時間，一定都要利用這些時間閒話家常，或設法問出對方比較難啟齒的話。這是一段引出對方沒有「防備」的「真實面」時間。

You have just a short window of time before you proceed from your meeting point to the place where your meeting is going to be held – a short interval after you arrive at the venue and sit down, but before the tea is served. I tend to make small talk that might be slightly awkward, or offer a listening ear to someone who might want to say the same. The answers aren't going to come rolling off the tongue, but they will get the message across.

要 特 別 醒 目

Find a name that stands out

包裝是產品的門面，所以最重要的是如何突顯這個產品，讓人一看就知道是這個產品，而且和別家的產品有哪裡不同。設計師通常很愛採用外觀美麗的視覺要素，以及看起來酷炫的歐文字體，但我們身處之地畢竟是在日本，除了必須追求美麗的設計外，更必須懂得用日文確實進行 PR。

The packaging is the face of your product. Find out what about it needs to stand out, so that consumers can recognize it instantly, or distinguish it from other products. Designers tend to resort to nifty graphic elements or cool-looking Eruopean fonts to make their work stand out, but this is Japan. You need a solid PR campaign in Japanese in addition to a cool design.

北海道産
本ずわい
がに 3,000円

試著以

的角度思考

Consider it as a product

提到年輕人想成為時尚設計師的動機時,最常聽的就是「想設計自己想穿的服裝」。雖然實際情形會因人而異,不過許多人根本還沒有累積設計核心所在的經驗,就只靠初期的一股衝動開始從事這個工作,最後只能在自我滿足下草草結束。其實應該先試著以「產品」的角度思考服裝,就會發現只要有設計圖(種類)和素材(布料),就能完成服裝。必須確實學會這些基礎,再來思考「自己想設計的服裝」。

An often heard reason for young people to become fashion designers is, "I want to design clothes that I want to wear". Although it depends on each person, many of them create with such early intentions but lack experiences that become the center of the design, and as a result they only please themselves. To start with, just consider clothes as "products". Clothes are made with patterns and materials. It's important to think about "clothes that you want to make" only after learning the basics.

到 視野 遼闊的地方看看

Get your bearings where the view is better

工作本來就經常讓人迷失,不妨多轉幾個彎,要是發現快搞不清楚
方位時,就走到大馬路去看一看。只要走到視野遼闊的地方,重新
確認一次明顯地標,就能繼續朝目的地前進。

You're going to lose your way many times. If you start to lose your way
after making too many turns, get out of there and make your way out
to the main road. Find some landmarks where you have a better view
of things, and make your way towards that direction.

試著賦予

價值

Assign value to what

you cannot see

賦予看不見的東西一個外形，再進一步讓它變成有形，就像被拍進
照片裡的被拍體一樣。從還看不見、還未成形的事物身上，讀取各
種條件後，讓它著地成形，雖然到此階段還無法看出全貌，但賦予
事物另一種看法，也是工作的一環。

Take invisible things that have already been given a form, and imbue
them with yet another form. This is analogous to the act of capturing a
subject through photography. Learn how to decode the various param-
eters pertaining to objects and things that aren't yet visible, or which
haven't taken on a palpable form, and nail them down. This isn't
necessarily crucial, but one of your jobs is to make obvious a particular
perspective and viewpoint.

去 旅 行 吧

Travel around

既然現今是個能輕易從網站上取得資訊的時代,就更該花點時間好好旅行一下,因為出去旅行,才能再度體認到經驗與某些資訊,其實不是那麼容易取得。

Precisely because it is an age when information can easily be obtained through the internet, spend time for traveling. By traveling, you can re-affirm experiences and certain kinds of information that can't be easily obtained.

從事彷彿在

讚美

人們的工作

Create work as if you were
paying someone a compliment

當被拍體就在眼前時，負責從中找出答案的是拍攝建築照片的工作。
此時拍攝的態度必須是肯定對方的，彷彿在大方的讚美對方的工作
即將順利結束一般。

The subject's already in front of you. Eliciting an answer from within it
is the job of an architectural photographer. The act of photographing
that subject ought to be affirmative in a way that allows you to shower
unreserved praise on a piece of work that has been completed without
a hitch.

將今日最棒的一刻

設為明日的最低底線

Today's best shot is tomorrow's
minimum requirement

今天能順利完成的事，明天必須更順利完成才行。已經會的事，絕
不能再失敗，我就是被如此教導的。最重要的事，就是清楚今天的
自己能做到什麼程度，並透過複習的方式延續到明天。

It's not always the case that tomorrow is going to turn out better than
today. But there are going to be superiors who believe that you should
do a better job the next morning for things than you can do today –
and have become particularly attached to their little slogan. Naturally,
you want things to turn out better than they stand today. In order for
that to happen, you need a clear idea of how well you did today.

試著擬定
問題1 到 問題5

Rank key challenges from 1 to 5

試著將客戶的需求設定成 5 個題目，並列為一整個問題。問題 1 與問題 2 屬於簡單的題目，問題 3 和問題 4 是應用的題目，最後的問題 5 則是綜合題。接著依序仔細解答，只要能解開簡單的問題 1，自然就能解開問題 2。之後利用這 2 題的答案，再繼續解開問題 3 和 4。雖然此時可能不易解答，但只要能解開，就有辦法解開問題 5，並得出最後的結論。不過一開始必須先仔細聽取客戶的需求，再決定設題與解題的順序，這都是非常重要的過程。

Whittle your client's demands down to a single issue that can be divided into 5 points. Address the simple things with the first two points, and the practical issues involved in points 3 and 4. Point 5 is the conclusion. Take care to solve each of these questions in turn – if you manage to solve number 1, the solution to number 2 will come to you naturally. You can then use the answers to these first two issues to tackle 3 and 4. Even if they're a bit trickier, solving 3 and 4 will allow you to address number 5 without a hitch, and lead you to your conclusion. Deciding how to tackle these issues in the right order after listening to your client's requirements is an important process.

ne washing……の洗濯物を

〜を引き抜く

and plastic bottles……カンやプラスチックのびん

nees……両ひざが悪い

ne snow……除雪する

……〜を植える

の内容に合うように，次の(1)と(2)の英語に書くものを
1つずつ選び，その記号を書きなさい。(各1点)

ア　Yuina saw a house on her way to school,

イ　and its garden had no weeds then.

ウ　and she knew that no one lived in i

エ　and her father knew who lived

　　and then she saw an old w

　　ing Community Beau

要討論就到 自己的 辦公室裡 進行

\ Hello ! /

Have meetings at your own office

辦公室最能展現當事者的設計態度，所以要討論就到自己的公司，直接呈現給對方看，這會比光用嘴巴說明，更能清楚傳達你的想法。不過辦公室的選擇，也會展現你的平衡感。以我為例，是選在千代田區設立辦公室，因為它地處東京正中心，能讓我全方位服務所有客戶，而不會有偏差。此外，從這裡要到外地或海外都很便利，是一個絕佳的出發點。

Your office sends a message to other people about your attitude to design, so invite clients over for meetings. Rather than explaining everything orally, your message gets across much better by having your clients see for themselves. Your sense of balance and judgment shows in where you decide to locate your office. I chose to base my firm in Chiyoda Ward because it's in the center of Tokyo, so that I can work with clients in every direction without being biased. Being here also gives me a good starting position that offers easy access to locations outside Tokyo or overseas.

不為自己的
工作
設限

Don't limit your scope

人們有時會因為職稱而為自己的工作設限，例如：攝影師、照相家、拍照家、攝影家等，雖然名稱都不盡相同，但不妨換個角度思考。此外，若能積極進行平常所為的小事，有時也會因而衍生出其他不同的活動。廣範圍的進行活動的結果，往往能成為這個人的特色，要是最後能因此得到某個職稱也很不錯。相反的，有時改變職稱的設定，也能擴展另一個新的工作。

Using names and labels like "cameraman" or "photographer" can sometimes place unnecessary limitations on your work. There are lots of titles out there, but make an effort to think of something different. There are also activities and projects that emerge because you've taken a more proactive approach to dealing with little everyday things. The results of a wide-ranging practice become trademarks, and hopefully bywords or calling cards associated with that person. Your career and future projects might flourish even more just by reconsidering the terms you use to refer to yourself.

① 要

② 重視

Make proper plans

③ 順序

將主管交辦的事、有期限或截止日的事，全部寫在紙上，因為只靠記憶的話很容易就會忘記，寫下來才能有助再度確認，而且也能因此賦予執行時的優先順序，建立出每件事在規定時間內所要完成的目標。當所有的事都能在一天內完成時，就能帶給自己自信，也能讓主管對你刮目相看，絕對能獲得一舉兩得之效。

Write out everything your boss has told you to do, as well as all tasks and appointments with confirmed dates and deadlines. You're going to forget if you just rely on your memory, so make sure to always double check. This way, you'll be able to order things according to priority, make sure to accomplish a certain task within the allocated time, and frame other concrete objectives. Not only will your self-confidence get a boost when you get everything done within a single day, you'll also make a great impression on your boss.

THURSDAY	FRIDAY	SATURDAY	SUNDAY
	31	1	**2** February 2014 如月
		休	18'生田スタジオ着 クランクアップ花束 宅間伸さん ¥3,000 AP菊地さん
st-by 資料作成 作成	7 市場(サンダース パト台) 8'30 角川大映画 クランクアップ花束 伊藤店 ¥2,000 AP久保田さん 16' LOGOS展覧会 バルン大オオ 19'ころ 目黒着 フジフラワー サンク木アレンジ ¥5,000 レンタル EASE 返却	8 休	9 st-by ↓ 8'ドリマ社着 クランクアップ花束 ¥3,000 ドリマ岡オ寸さん
花束休息展示会 ↓ st-by	14 市場(14,17,18日台) 10着 初台着 ワケありレッドゾーン引き込み 12'着 イスト アレンジ 舞浜メ5オ 14着 ネイチャーズウェイさん 花束朝引用 ¥4,200(税込) 大久保さん 14着 サンダーズさん 花束 サト台用 ¥2,000 小い中さん 20'着 ワケありレッドゾーン バルン	15 夜のみ 花束 st-by 休	16 6:45着 ドリマ着 クランクアップ花束 ¥5,000 ドリマ岡オ寸さん
未確認生物 2ケース AP吉良さん ツ西尾さん 資料集め	21 市場(21日台) 10' 六本木マッ 西尾さん shoca st-by ↓ PM着 緑がす アレンジ ¥10,000 フジフラワー 20' shoca返却 未確認生物 シタメ2ケース AP吉良さん	22 高原 st-by ←	23 6:45着 ドリマオ社在 クランクアップ花束 ¥3,000 メ2 芙ル木オ寸さん 8:40 ④ 銀座 たかとし涙がとまらなくト 3弟心本番 9'着 久我山 クランクアップ花束 ¥3,000 芙ル 中村さん 21' 銀座 たかとしバルン再入
st ストロングゼロCM ↓ 山鹿司会 t ストロングゼロCM	28 AM ストロングゼロCM片付け st-by 資料作成 ↓ 18:30 代々木公園 リっちゃん ウェディング	3/1 PM TMC-AI①コント の 稽古場 16' 次明台ST①王見台 ペセン～ 引込み 20'～ LOGOSイオ着売 バルン	2
	7	8	9

試著自然
無隔閡的
加以展現

Keep your work
natural and innocuous

要避免設計出讓人看起來非常個人化或太天馬行空的作品。能讓更
多人有似曾相識的感覺,看起來完全無隔閡的作品,才是完美的作
品。要讓作品看起來非常自然,又完全不礙眼,其實需要花費相當
大的勞力。

Avoid producing end results that are too individualistic or arbitrary.
Unassuming work is the result of a prolonged, accumulated sense of
déjà vu. Things that seem to have come about naturally, or which ap-
pear innocuous, often involve enormous amounts of time and labor.

實際到
現場去
四處
走動

Do your site recce

在工作現場裡要盡量做到融入其中，例如在拍照攝影的現場裡，為
了與該空間同步，要先不斷的四處走動，彷彿在做運動前的暖身操
一樣，之後不停歇的連續拍攝時，步調就會更一致。等完全融入該
空間，也習慣所有拍攝的角度後，身體大概也累了，此時自然會開
始鬆懈下來，不過這樣也還是能拍出不同味道的好照片；至少有時
是如此。

It's a good idea to get properly acquainted with the site you'll be
working at as soon as possible. Walk around as if you were warming up
before exercising in order to get in tune with the space. You'll synchro-
nize even better with the location by shooting continuously, so that
your "flow" won't be interrupted. When you start to tire of the familiar
angles and objects within that space, a certain sloppiness will begin to
show, and you can sometimes just shoot it that way.

尊重前人 所建立 的 價值

Respect the values put in place
by those who came before you

要明白多虧有前人建立特定的領域,現在的我們才有這份工作可做。以拍照為例,照片的價值、美麗的基準、拍攝的角度、禮儀作法等都是如此。一定要時時提醒自己,絕不能冒瀆前人所建立的價值。

You're able to pursue the work you do today thanks to the specific genres created by your predecessors. In the case of photography, this includes the values associated with the medium, aesthetic criteria, camera angles, and established protocols. Make sure you don't devalue the foundations that these people have built.

設法讓

條件

站在 你這一邊

Turn your circumstances to your advantage

工作的條件基本上是外加的，是由他人訂定的，你只能在這樣的制約裡展現成果，而若想進一步在有限的時間裡拿出成效，就必須判斷時機、工期、氣象等種種條件，可說是屬於「被動的一方」。為了在有限資源裡留下最極致的成果，就必須設法讓條件站在你這一邊。

The conditions that govern your work all come from the outside. Typically, you're working to craft something out of the restrictions and limitations that arise from what other people have already put in place. In order to produce results within a limited time frame, you have no choice but to make decisions based on timing, the time period given to you, and the weather conditions involved – basically, working from a defensive or passive position. In order to have maximum impact, you need to turn the given circumstances to your advantage.

擁有
純真的心

Keep your heart and mind pure

累積了經驗且有了一定年紀後，更應提醒自己以純真的眼光來看待事物，用開朗的心來思考事物，不讓自己變成一個對萬事萬物都「習以為常」的人。要感謝願意批評你的人、願意對你生氣的人，唯有抱持「我還不成氣候」的態度，才能為未來的自己與工作帶來正面的影響。

Make a conscious decision to look at things with a clear mind unclouded by preconceptions after you've chalked up years of experience, and try to tackle things with an open mind. Don't let yourself "get used" to anything. Be grateful to nitpickers and those who get mad at you. Staying humble and modest about your own abilities will have a direct impact on how you develop in the future, and the work that you'll be capable of.

Keep to an ideal size

思考
恰到好處的

組織規模

要維持工作品質需要哪種規模的組織，這一點絕對不能估算錯誤，
因為當人數超過一定的規模時，往往就是工作品質開始大為降低的
時候。要確保值得被期待的工作品質，就必須依據工作內容與管理
者的能力，找出最佳的組織規模。

Never misjudge the appropriate scale of the organization required to
maintain the quality of your work. The moment the number of staff
exceeds a certain limit, the standard of their work is going to nosedive.
In order to maintain the quality of work expected, you need to find
an ideal size and scale for your organization that corresponds with the
content of the work and the abilities of your managers.

理解金錢所代表的意義

Understand the
meaning of money

「日本人真的都很善良。」這句話在國內聽起來是美德，但在海外的商場上，等於是被在罵笨，因為在國外，「商場」就等於「金錢」，「自己所提示的金額高低」就等於「自信的高低」，有時刻意提高價錢反而能得到更高的評價。相對的，無償提供設計案時，就像是允許對方吃霸王餐一樣，但實際上去餐廳時，你一定不敢向店家說：「必須是最好吃的，我才要付錢！」吧。除非你明知這一點，還願意抱持覺悟擬定戰略，那就是你自己的選擇。

"Japanese are very nice." Even if it's a virtue in Japan, it is a contemptuous saying in international business situations. Overseas, business equals money. Your offering price shows your degree of confidence. Sometimes a more expensive offer is more highly-regarded. Meanwhile, proposing a design for free is like forgiving a person who eats and runs. Would you be able to say at a restaurant, "I'll only pay if the food is the best-tasting"? With this in mind, it is OK to respond strategically.

持續

活 USE 用 ／ 善 LIVE 用

設計

Keep making good use of that design

設計只要一離開創作者的手，就再也無法掌控。要讓設計成為過去式，還是持續活用到未來，這完全看設計師的心態。要持續活用設計就要懂得維護，而活用設計屬於 PR 的領域。因此千萬別忘了作品完成後並不代表結束，而是之後仍持續在一較高下。

Creators lose control of their design once it leaves their hands. It's entirely up to the designer whether he consigns his design to the past, or decides to continue leveraging and making use of it. There's a lot of maintenance work that needs to be done so that your design continues to shine and be of use. Making continued use of that particular work is also something that you can entrust to your PR campaign. The ultimate goal shouldn't be the point at which the work comes into existence. Don't forget that your design needs to continue to excel long after that.

Past Take the long view Future

以長遠的時間軸來思考自己的工作

不論從事哪種工作，都不能以瞬間來思考，必須明白你的工作是在承接對方過去的時間，並將之送往未來，只要這樣思考就會發現意義完全不同。你的作品很可能會歷經一段「被不特定的多數人看到」的時間，只要如此想像，就讓人覺得興奮無比。

Whatever the job may be, don't think of it as a one-off, transient thing. The work takes on an entirely new meaning if you look at it as an extension of the time that the other person has already invested, and something that you offer up to the future. You won't be able to just sit around idly if you imagine all those eyes watching what you do, whether now or sometime in the future.

要抓住

Happiness through the stomach

若想拉近與員工之間的距離，最快的辦法就是請員工吃美食，因為被人請吃美食時，都會對那個人抱持好感，說這是人類的本能一點都不為過。不過絕對不能忘記利用這段時間好好聽員工說，甚至讚美員工。簡單來說……就像和「談戀愛」時一樣。

If you want to break the ice and bring your staff closer together, pull out all the stops and take them out for a fantastic dinner. It's only natural to have a good impression of someone who lavishes all that good food on you. And don't forget to listen to all their little stories and gossip and shower praise on them – just like you'd do with your lover, basically.

利用出版品的力量
朝下一個階段前進

Use the power of print to get to
the next level

幾乎所有設計師在成名後，都會以自己早期的工作經驗為主出書，
或接受知名雜誌採訪並被刊載發行，進而因為這些評價而更廣為人
知。設計這種工作其實很容易變得乏味，因此要盡量利用出版品來
取得榮耀，進而獲得社會的信賴。與出版社維持良好關係，對設計
師絕對有很大的幫助。

Almost all the designers who went on to become famous published
books early on in their careers and were featured in top magazines
– which then helped them to win even more recognition. The actual
work of design tends to be fairly low-key, so you should turn to paper
media to chase the glory you've been looking for, and win some mea-
sure of trust and respect from the public. Getting friendly with publish-
ers will give designers that extra edge.

腕のいい
デザイナーが
必ずやっている
仕事のルール125

仕事の
取り組みかたから、
人間関係
デザインフィー、
マネジメント、
部下の育成まで

X-Knowledge

不將工作當成 興趣

Don't make your work your hobby

「我的興趣是工作！」如果有這種員工，一定要立刻砍頭，而且雇用這種員工進來的經營者，也應該跟著切腹。基本上興趣這種東西是空閒時所做的休閒活動，屬於一種享樂活動，所以如果有人抱著「下次休假時就來工作吧！」的享樂心態來工作，叫人怎麼受得了。

If any of your staff tells you that their hobby is their work – off with their head! The manager who hired the guy ought to be done away with, too. A hobby is something you enjoy at leisure during your down time, for recreation or amusement. "The next time I get a free moment, I'm going to get some work done!" Being made to slog away for fun is simply inexcusable.

臨時

多出來的

時間

一定要好好的

加以活用

Make good use of
unexpected free time

開暇時的時間使用法非常重要。當工作很多時，不論誰都有辦法忙碌的將工作處理完，但對工作來說，要想長久持續下去，最重要的反而是在工作出現空檔時，要如何運用那段時間。

Be careful how you allocate your time when you're not that busy. Anyone can attend frantically to a heay workload when the going gets tough. What you really need to know in order to carry on working over the long haul is how to get through those times when the work just completely dries up.

將壓力轉為歡喜

Convert pressure to pleasure

從事設計業的宿命，就是得持續的背負著壓力，畢竟是在連自己也
不知道正確答案的情況下，被委託在有限的時間內完成工作，所以
若想在設計業得到成功，就只能設法學會將壓力轉為歡喜。會有壓
力表示受到期待，而比起不被人期待，被人期待總是比較幸福吧？
若能以取悅對方為主來思考，表示你已經是一個及格的設計師。

Design work is destined to produce constant pressure, since you get
a work offer with a deadline but you don't have an answer. To make a
living by designing, you must learn techniques to convert the agony of
pressure into pleasure. Pressure is the flip side of the client's expec-
tations. Isn't it better to have high expectations for you than to not?
When you can think of how to provide pleasure, you are a full-fledged
designer.

延續樂觀的態度
並轉為工作的原動力

Turn your optimism into a motivating force

若能以樂觀為前提而展開工作，那就再好不過。婚禮、七五三、旅行紀念等照片，都能讓人想起開心的事。建築照片也是一樣的，永遠存在想將美麗的東西永久保存下來的樂觀前提，但在共享美麗照片的同時，也別忘了照片還肩負著被當作是建築物未來藍圖的驚人現實，也已經開始啟動了。

The premise of your work is that these photos will be the start of something big. We associate photographs with happy events and occasions, like weddings and vacations. The same is true of architectural photography – it exists because we want to create an aesthetically pleasing record of these beautiful buildings for posterity. Although your work serves to share this particular moment with other people, you also need to be aware of the slightly frightening fact that these images are going to become a future document of these architectural works.

試著發揮你的想像力

Fire up your imagination

生於這個時代，海外會突然發來 e-mail 委託你工作或合作，一點也不奇怪。甚至常常只靠電話或 e-mail 的聯絡，就開始執行工作直到結束。因為彼此不見得都以英語為母語，所以有時會因溝通上出現誤解，而讓你覺得很懊惱，但此時你若放棄的話那就完了。不妨將這種情形當成心靈溝通，站在對方的立場思考，只要從字句意思全面發揮你的想像力，要與全世界的人取得溝通都不是難事。

These days, it's not uncommon for an email from a foreign client to suddenly appear in your inbox with an offer of work or a proposal to collaborate. Projects can get off the ground or shelved just through the telephone or email. It can be an utterly frustration experience when misunderstandings occur among people whose first language is not English – but once you give up, that's the end of the story. Try putting yourself in the other person's shoes and thinking about things from their point of view – just as if you'd teleported yourself next to them. Fire up your imagination and decode those nuances, and you'll find that it's not such a stretch to communicate with people from all over the world.

宛先: ◎ oshigoto@gmail.com
CC:
件名: تخطيط الكتب والمج
添付ファイル: なし

Courier New | 12 | **B** *I* U T

تحية طيبة وبعد

اسمحوا لنا أن نقدم لكم شركتنا التي تعمل في مجال التصميم والتحرير والكتابة، وتتخصص في تصميم وتخطيط الكتب والمجلات والنشرات والمطبوعات الإعلانية عن طريق النشر المكتبي (TP)

رفنا على شركتكم الموقرة بعد أن رأينا موقعكم على الانترنت، وسيكون ل جزيل الشرف إذا وافقتكم على التعاون معنا عن طريق تعهيد جزء من أعمال شركتكد

لم تتمام أقدر إنشغالكم بأعمال كثيرة، ولكن سنكون في غاية الامتنان إ تكرمتم بتحديد موعد للمقابلة حتى نشرح لسيادتكم كافة التفاصيل الخ بشركتد

نشكركم على اهتمامكم بهذا الأمر وفي إنتظار ردكم لتحديد موعد للمقاب

وتفضلوا بقبول فائق التحية والاحت

試著設計作品之外的設計

Design something other
than the product itself

不論你能交出多漂亮的成績單，都絕不能忘記，你的客戶是同時在觀察整個設計過程，以及你的人品。交出漂亮成績單是理所當然之事，既然成果一樣，那評價的好壞又差在哪裡？要能連這一點都設計進去，才是真正的設計師。

No matter how great a job you manage to do, never forget that your clients have their eyes on the entire process, and your own personality. Clients expect great results as a bare minimum. If the end product is the same, what's going to make the difference? Only when you manage to "design" these other aspects of your practice can you call yourself a real designer.

A B C D E F G

H I J K L M N

O P Q R S T U

V W X Y Z

從永不過時的事物身上找出新的事物

Discover newness
in things that
don't get old

能創造出新事物的人，是因為有能力比別人早一步注意到大家都沒注意到的事，有能力預見世上還沒推出的東西，或是具有強大的假想能力。然而找出與眾不同的全新事物的行為，並非設計原本的價值，因此不能對這一點抱持過度的執著。新的事物其實也大量存在眼前，只要懂得將既有的東西重新組合，就能不斷創造出新事物。永不過時的事物，才是唯一的新設計。

Being able to produce something new is really about the ability to realize quickly what others haven't, to foresee things that haven't appeared yet, or to have a certain hypothetical, imaginative vision. Discovering something new and original that is different from everything else out there is not what design is good for, so you shouldn't obsess over that more than necessary. There are lots of new, fresh things are right there in front of you. All the originality and newness you want are yours for the taking, as long as you combine these things in the right way. Things that don't get old are the only "new designs" there are.

資訊要透明

ㄗ ㄒㄩㄣˋ ㄧㄠˋ ㄊㄡˋ ㄇㄧㄥˊ

Make information clear

想瞭解你的人，都希望能簡單明瞭的得到和你相關的資訊，因此不必設計華麗的網頁，也不必製作理念跟深難懂的作品集，只需傳達簡潔有力的訊息、記載淺顯易懂的內容。當然也絕不能疏於更新訊息，才能讓公司具有更完美的 PR 體質。

People who want to know more about you are looking for information that's easy to understand, more than anything else. You don't need a fancy website or portfolio with a complex concept in tow. What matters is a simple, concise message and clear-cut presentation. Just by not being lazy with updates, your firm is going to get a solid PR boost.

從事
能和對方面對面的工作

Face time is important

工作時要能實際看見對方的人，才有辦法跳脫工作關係的框架，以「人」的立場來看對方。一旦觀察出對方的個性，就能幫助自己更用心看待這個工作，將對方的事當成自己的事來處理。

You learn to appreciate your clients and colleagues as individuals by interacting with them face to face. When you get a glimpse of what it is that makes people unique, work will stop being just work, and other people's work will become something personal to you, too.

Start　　　　　　　　　　　　Time limit　　　　　　　　Delivery

遵守時程規劃

Keep to the schedule

「多花一點時間執行，才能完成好的工作、好的設計。」這句話是真的嗎？既然是從事製造產品／設計的工作，就一定會有發出工作的雇主，而雇主者當然會考量銷售時間來擬定銷售計畫，所以遵守時程規劃，在規定的時間內完成產品，絕對是一件重要的事。

Spending more time will lead you to a better end product and design. Is that really true? People who make or design things for a living necessarily work for clients or outsourcers who have undoubtedly drawn up a sales plan that takes into account when the product will hit the market. Working on schedule and producing results within the stipulated time are also important.

面對
愈有名的人
愈要以
先生 或 小姐
稱呼

Pay more respect the more famous the person is

與人談到知名的設計師時，一定要加上「先生或小姐」，即使是在談話中要引用不曾謀面過的知名設計師時也一樣，絕不能說：「安藤忠雄他……」當你連先生這個尊稱都不說時，表示你永遠也不可能和安藤先生站在同一個層級上。

When referring to famous designers in conversation, make sure to call them "Mr./Miss". Never refer simply to "Tadao Ando" or other well-known designers whom you haven't even met without using an honor-ific. You'll never join the same league as Mr. Ando as long as you refer to him like that.

Q. 提出最棒的問題

Ask great questions

A. _____

對事物抱持旺盛的好奇心,是讓你提出獨創性問題的原動力。設計的力量不在於提出解答,而在於是否有能力就各個領域提出全面性的問題,能勇於面對這些問題的態度,才是製造產品的精髓所在。最棒的問題,一定會有最棒的解答。

Curiosity is a measure of your passion for coming up with creative and original questions. The power of design lies not in the answers it can proffer, but rather in how it can ask broad, all-encompassing questions about a particular domain. The real pleasure of making things comes from confronting these questions. The answers to great questions are necessarily going to be great, too.

PROFILE

宇野昇平 SHOHEI UNO

藝術總監

P. 38, 86, 92, 116, 196, 240, 244, 254

1970 年生，東京都人。1995 年從日本大學研究所理工學研究科畢業後，曾服務於建設顧問／設計公司，之後成立 SURMOMETER INC.，利用各種媒體負責 PR、廣告、工具類企劃、書籍監修等工作，而且領域涵蓋土木／建築到時尚、食品等，範圍相當廣。同時擔任「工藝うつわと道具 SML」的採購／總監。

喜多幸宏 YUKIHIRO KITA

編輯者‧總監

P. 30, 66, 108, 138, 160, 180, 188, 200, 262

1972 年生，愛知縣人。文科系畢業後，曾服務於出版社，之後成為自由工作者。從建築到食品等，負責各領域的企劃與監督等工作。

木村 茂 SHIGERU KIMURA

不動產顧問

P. 56, 80, 84, 94, 134, 150, 174, 178,
232, 246, 264

東京都人。1989 年從早稻田大學法律系畢業後，曾服務於 CI 顧問公司（PAOS）等處，2000 年時成立 TRANSISTOR 公司，擔任負責人一職，同時也是住宅建築交易主任、住宅貸款顧問、公認不動產顧問經理。以建築師夥伴的身分，提供具有設計精神的不動產顧問、仲介、財務顧問等服務。

國時 誠 MAKOTO KUNITOKI

時尚設計師

P. 54, 152, 156, 172, 194, 202, 208

1975 年生，群馬縣人。2001 年畢業於武藏野美術大學造型系空間演出設計科時尚組。是時尚品牌「STORE」的負責人，推出以所有產品都是獨一無二為最大特色的「條紋系列」服飾，還負責舞台服裝，並在日本各地舉辦以衣服為主題的工作室和藝術展，同時也是區域緊密型藝術專案「TERATOTERA」的總監，活躍領域相當廣。

黑崎 敏 SATOSHI KUROSAKI

建築師

P. 12, 14, 16, 20, 26, 28, 34, 76, 96, 98,
102, 104, 110, 112, 126, 130, 154, 158, 164,
166, 168, 176, 216, 256, 266

1970 年生，石川縣金澤市人。1994 年從明治大學理工系建築科畢業後，曾服務於某廠商、設計師事務所，2000 年時成立 APOLLO 一級建築師事務所，目前擔任負責人一職，同時擔任慶應義塾大學研究所理工學研究科的兼任講師。以住宅及辦公大樓為主，提供國內外相關的設計與顧問等服務，得過 GOOD DESIGN AWARD、東京建築獎、日本建築家協會優秀建築選等許多獎項。主要著作有《新しい住宅デザインの教科書》、《最高に楽しい家づくりの図鑑》（皆由 X-Knowledge Co., Ltd. 出版）、《可笑しな家》、《夢の棲み家》（二見書房）。

戶恒浩人 HIROHITO TOTSUNE

照明設計師

1975 年生，東京都人。1997 年從東京大學工學系建築科畢業後，曾服務於 Lighting Planners Associates（LPA）公司，2005 年時成立 SIRIUS LIGHTING OFFICE。活用建築與環境照明、都市計劃等豐富經驗，不斷的擴展其活躍的領域。負責過以東京晴空塔為首的日本國內各建築的照明，也在海外大型建築物裡留下不少實績。2013 年獲得北美照明協會的照明設計獎冠軍。

鳥村鋼一 KOICHI TORIMURA

攝影師

1976 年生，千葉縣人。1999 年從明治大學理工系畢業後，曾服務於 Nacasa & Partners，2007 年時成立鳥村鋼人寫真事務所，擔當該事務所負責人。持續拍攝著住宅、辦公大樓及公共設施等空間，非常受建築師信賴。

藤原佐知子 SACHIKO FIJIWARA

花藝設計師

千葉縣人。私立高中畢業後，曾服務於富士電視台，擔任花藝裝飾工作，之後成立渚華 -shoca- 股份有限公司，擔任負責人一職。不論鮮花或人造花，提供有聖誕節應景花飾與各種花飾，也負責提供室內裝潢的造型設計服務。

269

武藤智花 CHIKA MUTO

建築設計專業 PR

武藏野美術大學畢業後，曾服務於 Klein Dytham Architecture，擔任公關、行政主管、活動經理等工作，負責的工作為協助建築師。2006 年時成立 NEOPLUS610，擔任負責人一職，並以建築師和設計師為對象，提供對海外的交涉與 PR 等服務。

渡邊謙一郎 KUNICHIRO WATANABE

STANDARD TRADE. 負責人

1972 年生，生長於橫濱。神奈川大學建築系畢業後，開始學習製作家具，並畢業於品川職業訓練學校。為了提供一般住家簡單又優質的家具，於 1998 年成立 STANDARD TRADE. 公司，致力於原創家具的設計、製造與銷售，因高水準技術與空間的協調性而深受好評，同時負責住宅、辦公室和店面的設計工作。而且也修理、修復、重建過無數知名的家具，一樣受到很高的評價。

| 照片 | 烏村鋼一 |
| | P. 53, 63, 149, 193, 207, 219, 223, 229, 239, 251 |

烏村鋼一
P. 53, 63, 149, 193, 207, 219, 223, 229, 239, 251

西川公朗
P. 97, 111, 151, 257

高野尚人
P. 29, 133, 143, 189, 243

Getty Images
P. 9, 11, 25, 35, 39, 43, 45, 47, 49, 51, 69, 73, 79,
83, 87, 119, 147, 153, 157, 167, 181, 209, 213, 225, 231, 235

amanaimages
P. 17, 21, 41, 55, 57, 59, 61, 65, 67, 71, 77, 81,
109, 137, 145, 161, 171, 177, 179, 185, 187, 195, 199, 227, 237, 241, 247, 263

PIXTA
P. 27, 115, 155, 215

小谷田整／Aflo P. 31　Newscom／Aflo P. 33　築田純／Aflo Sport P. 85
讀賣新聞／Aflo P. 89, 117, 169, 197, 211　日刊體育新聞／Aflo P. 95
AP／Aflo P. 103　DUOMO Photography／Aflo P. 107　Fortean／Aflo P. 125
丹羽修／Aflo P. 139　松岡健三郎／Aflo P. 141　中村吉夫／Aflo P. 175
Asia Images／Aflo P. 191　Splash／Aflo P. 203　川北茂貴／Aflo P. 205
路透社／Aflo P.259　平工幸雄／Aflo P. 261　每日新聞社／Aflo P. 265

照片　烏村鋼一

翻譯（英文）	武藤智花（NEOPLUS610）
設計・DTP	宇野昇平、五木田裕之（surmometer inc.）
插圖	小寺練（surmometer inc.）
共同編輯	加藤純（context）

UDE NO II DESIGNER GA KANARAZU YATTEIRU
SHIGOTO NO RULE 125
© SHOHEI UNO & SHIGERU KIMURA & MAKOTO
KUNITOKI & SATOSHI KUROSAKI & HIROHITO
TOTSUNE & KOICHI TORIMURA & SACHIKO
FUJIWARA & CHIKA MUTO & KENICHIRO
WATANABE 2014
Originally published in Japan in 2014 by X-Knowledge
Co., Ltd.
Chinese (in complex character only) translation rights
arranged with X-Knowledge Co., Ltd. TOKYO,
through TOHAN CORPORATION , TOKYO.

國家圖書館出版品預行編目資料

創意無界！優秀設計人思維大不同 / 宇野昇平
著；蕭雲菁譯 .-- 初版 .-- 臺北市：臺灣東販，
2015.01
面；　公分
ISBN 978-986-331-594-0(平裝)

1.設計　2.創意　3.個案研究

960　　　　　　　　　　　　　103024307

創意無界！
優秀設計人思維大不同

2015 年 1 月 1 日初版第一刷發行

作　　　者	宇野昇平、木村茂、國時誠、黑崎敏、戶恒浩人、 鳥村鋼一、藤原佐知子、武藤智花、渡邊謙一郎	
譯　　　者	蕭雲菁	
副 主 編	陳其衍	
美術編輯	張曉珍	
發 行 人	齋木祥行	
發 行 所	台灣東販股份有限公司	
	＜地址＞台北市南京東路 4 段 130 號 2F-1	
	＜電話＞ (02)2577-8878	
	＜傳真＞ (02)2577-8896	
	＜網址＞ http://www.tohan.com.tw	
郵撥帳號	1405049-4	
新聞局登記字號	局版臺業字第 4680 號	
法律顧問	蕭雄淋律師	
總 經 銷	聯合發行股份有限公司	
	＜電話＞ (02)2917-8022	
香港總代理	萬里機構出版有限公司	
	＜電話＞ 2564-7511	
	＜傳真＞ 2565-5539	

本書若有缺頁或裝訂錯誤，請寄回更換。

Printed in Taiwan.